P9-CQV-914

# *Bloomington* PAST & PRESENT

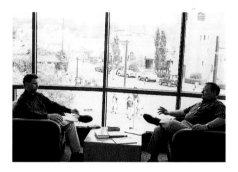

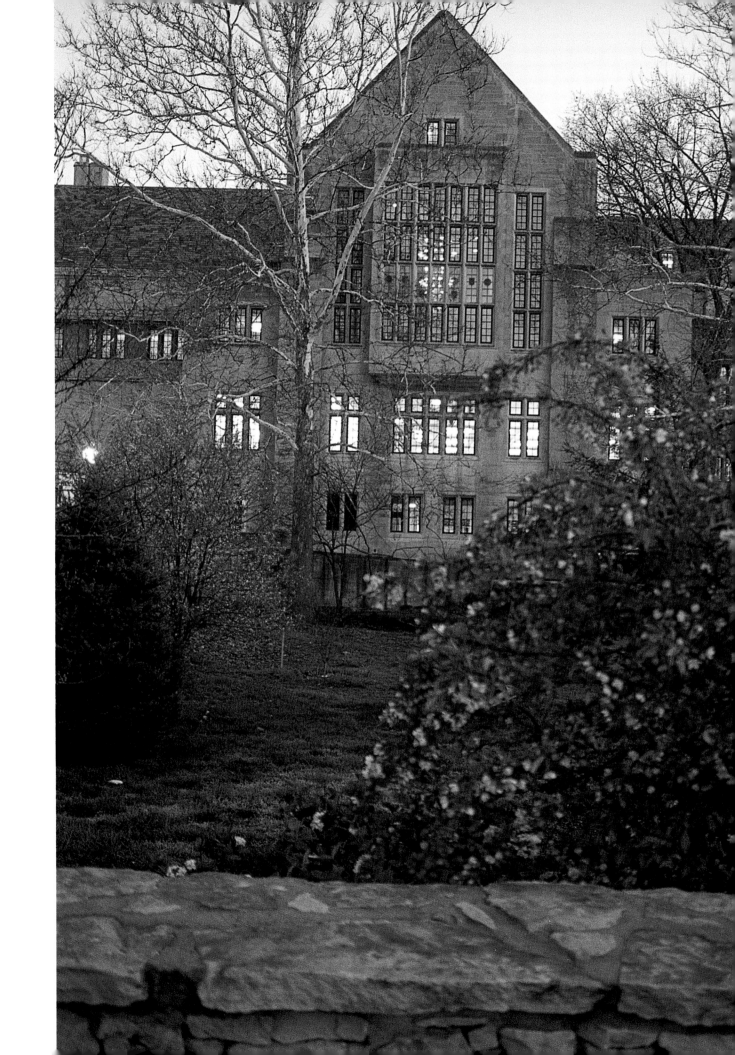

*Will Counts,*
*James H. Madison,*
*and*
*Scott Russell Sanders*

*Bloomington*
PAST
&
PRESENT

INDIANA
University Press    Bloomington & Indianapolis

i — Howard Boles (*left*) and Dean Roller settle into comfortable chairs in the Monroe County Library. While the holdings of this community library are dwarfed by those of the Indiana University library located a few blocks away, its location on Kirkwood Avenue places it in the center of campus and community life. Spring 2001.

ii — Lights glow from within the Indiana Memorial Union building at dusk. The IMU is one of the largest college unions in the world. 1990.

viii — Kids play in the fountain in front of Bloomington's Showers City Hall. The fountain is a favorite place for children to gather while their parents shop at the Farmers' Market nearby. August 2000.

xi — A student sits on a bench in front of Owen Hall, next to a statue of Herman B Wells that was placed in the Old Crescent area of the IU Bloomington campus in the fall of 2000. Wells served as IU's president from 1938 until 1962, when he became university chancellor. He died March 18, 2000, at the age of 97.

PHOTOS BY WILL COUNTS

This book is a publication of
*Indiana University Press*
601 North Morton Street
Bloomington, Indiana 47404-3797 USA

http://iupress.indiana.edu

*Telephone orders*    800-842-6796
*Fax orders*           812-855-7931
*Orders by email*      iuporder@indiana.edu

*The paper used in this publication meets the minimum requirements of American National Standard for Information Sciences—Permanence of Paper for Printed Library Materials, ANSI Z39.48-1984.*

MANUFACTURED IN CHINA

**Library of Congress Cataloging-in-Publication Data**

Counts, I. Wilmer (Ira Wilmer), date
    Bloomington past and present / Will Counts, James H. Madison,
    and Scott Russell Sanders.
      p.   cm.
    ISBN 0-253-34056-X (cloth : alk. paper)
    1. Bloomington (Ind.)—History. 2. Bloomington (Ind.)—
Description and travel. 3. Bloomington (Ind.)—Pictorial works.
I. Madison, James H.    II. Sanders, Scott R. (Scott Russell), date
III. Title.

F534.B6 C68 2002
977.2'255—dc21  2001039871

1  2  3  4  5  07  06  05  04  03  02

*In memory of* HERMAN B WELLS

*citizen of Bloomington and the world*

*and*

*In memory of* WILL COUNTS

# CONTENTS

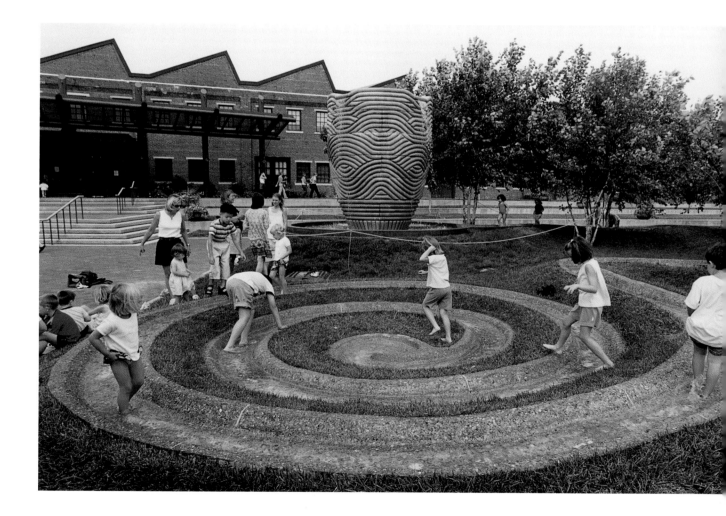

# PREFACE

Good places are shaped by the gifts of nature and by the labor and love of many people over generations. The city of Bloomington, tucked away in the forested hills of southern Indiana, is one such place. Three of us who have worked here, played here, reared children here, and set our roots right down to the limestone bedrock made this book to chronicle and celebrate our home town.

Bloomington has long attracted and nurtured artists, including musicians, actors, sculptors, painters, poets, and a series of remarkable photographers. Will Counts has gathered in these pages some of his own photographs taken over a long career, together with photographs by more than a dozen other fine artists. Some drawn from archives, some taken recently, these images reveal the city's textures and energies, its pageants and personalities, along with its buildings and landscape.

The essay by Scott Sanders leads the reader on a walk through Bloomington today, evoking the feel of the city, its human fabric and natural setting. The stroll begins in a patch of venerable woods preserved on the grounds of Indiana University, then proceeds westerly across town, ending in a cemetery filled with stories. In between, the reader is invited to savor the smells of cuisines from

around the world, the old buildings restored to new uses, quirky shops and workaday businesses, and residential neighborhoods featuring big trees and deep porches and children at play.

Jim Madison writes about what Bloomington once was, tracing changes in the community from the nineteenth century, when it was so much like other Midwestern towns, on through the twentieth century to the complex and vibrant city it is today. This history has not been free of shadows, especially as the small town struggled to embrace an increasingly diverse population. While not paradise, the modern city has worked toward a rare and precarious harmony between town and gown, between rich and poor, and among people of widely varied ethnic and racial backgrounds.

Through words and images, we hope to share our affection for Bloomington with those who are visiting, those who dwell here for a while, and those who plan to stay here as long as they breathe. If you add together our years of residence, the three of us have now spent slightly more than a century here, and we are still learning about our home. At once a Midwestern county seat, a college town, and a cosmopolitan center of culture, Bloomington offers riches out of all proportion to its size. We relish the artistry, the history, the moods and manners of this place, while realizing that much of what we value here may be lost through neglect or thoughtless growth. What's good about this place, or any place, depends for its preservation on the commitment and care of citizens. So we invite readers not merely to enjoy the city but also to defend what's worthy here and to help make a good place even better.

Between the completion of this book and its publication, Will Counts died. He was ill during our two years of collaboration, but you would never have guessed it from the way he worked. As we sat at his dining table, comparing our visions of Bloomington, the roar of his laugh would startle birds from the feeders outside the window, and the purr of his Arkansas voice would turn every anecdote into a memorable tale. He searched through hundreds of photographs, looking for eloquent images. The ones that Will chose to include in these pages pay a double tribute—to his home town, and to his own keen and compassionate eye.

# ACKNOWLEDGMENTS

Among the many people who have nourished the best qualities in our city, and among the generous souls who have helped us in making this book, we wish to thank Tomi Allison, James Capshew, Bill and Gayle Cook, Jean and Don Cook, Claudia Counts, Vivian Counts, Wyatt Counts, John Fernandez, John Gallman, Diana Gros Louis, Warren Henegar, Jeanne Madison, Frank McCloskey, Glenda Murray, James Rosenbarger, Ruth Sanders, Barb and Chris Sturbaum, Bill and Helen Sturbaum, and Charlotte Zietlow. Bradley Cook of the Indiana University Archives was a major help in locating the historical images, and Brad Jacobs helped with lab work on the photographs. We are also grateful for assistance from the Monroe County Library, particularly the Indiana Room librarians, and the Monroe County Historical Society. Finally, we wish to honor the man to whom this book is dedicated, the late Herman Wells, who invested himself in this community with genius and grace.

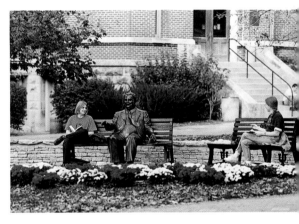

*Scott Russell Sanders*

# Loving This Place

Suppose you and I are old friends. We haven't seen one an-
other for years. You've been living in a glamorous place that's often
featured in films and travel brochures, and I've been living in the
hill country of southern Indiana, a place that hardly ever shows up
on glossy pages or big screens. Wondering what keeps me here in a
town called Bloomington, you decide to pay me a visit so you can
have a look around. I warn you to wear comfortable shoes, because
we'll do most of our looking on foot.

On our drive back from the airport in Indianapolis, I pull off
the four-lane highway to approach town along Old State Road 37.
By taking that route we avoid the billboards, those ugly blots, and
we follow the contours of the land, rising and plunging. You're sur-
prised by the swerves; you thought Indiana was flat. Thanks to the
glaciers, the northern two-thirds of the state *are* pretty flat, I tell
you, but the ice ground to a halt some twenty miles north of
Bloomington. These hills and valleys we're winding through are
the remains of an ancient seabed, mainly limestone, siltstone, and
shale, scoured by erosion for the past hundred million years.

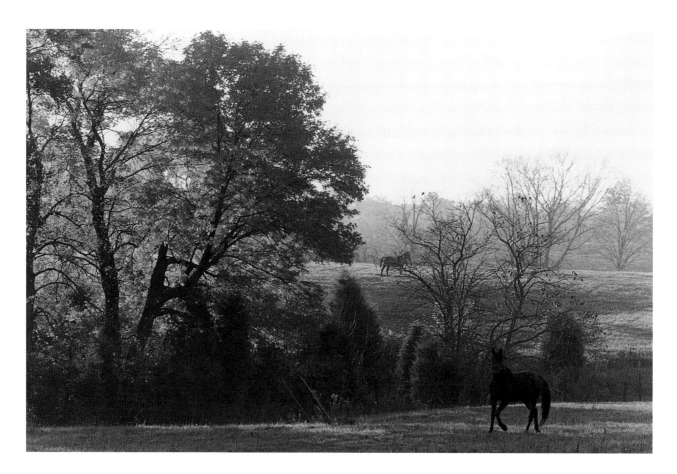

Early morning sunlight illuminates the fall foliage as horses graze in a field along Kinser Pike on Bloomington's north side. 1990. WILL COUNTS

Except in bottomlands along rivers and creeks, the soil is thin, not much good for growing crops but superb for growing trees. That's why Bloomington is encircled by public and private forests. As we near town, trees crowd the edges of the road, forming a vault of branches overhead. Depending on the season of your visit, those limbs will simmer with the pale green flames of spring leaves, sway with the weight of summer's dense foliage, burn with autumn's fiery colors, or flare with a bold tracery against the winter sky. If you happen to visit in summer, the crops in the bottoms will be soybeans or corn. You'll see a few hogs rooting in muddy barnyards, a few cows, horses, and sheep grazing in pastures, but no big livestock operations. There's a good chance you'll see deer, a slim chance you'll see wild turkey or coyote or fox. These fields and farms, even the towns, are only clearings in the woods. Quit mowing, quit paving, and before you know it briars and saplings will reclaim any bare ground.

The last thick woods we pass before reaching town border Griffy

Lake, a reservoir that slaked Bloomington's thirst from the 1920s into the 1960s, when larger reservoirs were built elsewhere in the county. Now the lake is the bright watery eye at the center of a nature preserve, one of my city's treasures. If we have time during your stay, I'll take you canoeing there. For the moment, we'll cruise past a softball field, a limestone quarry, a trailer court, and a park known as Cascades, because it hugs the sides of a brook. From the park we'll take a small detour, no more than a couple hundred feet, to the base of a bluff. If we were to drive up the hill, we'd come to a golf course, one of several in the city, but we won't do that, because you didn't travel all this way to gaze at vapid fairways.

What we're looking for is at the bottom of the hill, near the bank of the stream: a flat-roofed house painted canary yellow, with orange trim, blue awnings, and a front door as gaudy as the lid of a music box. Flags wave from ropes strung between trees in the yard, and the blacktopped driveway is ornamented with figures and words in white paint, including this greeting:

WELCOME
PEACE OF MIND

Set down here within a stone's throw of the trailer court, the place looks as though it might have come from another planet, but in fact it comes from the other side of the earth, for this is a Tibetan Buddhist monastery. It may seem odd for monks in exile from Tibet's cold mountains to be studying Buddhism between a golf course and a limestone quarry in southern Indiana, but here they are, and happily so by all accounts. Such contrasts give spice to this town.

*We* drive back onto the old state road, then up the grade past a motorcycle repair shop

SCOTT RUSSELL SANDERS

3

A long-life ceremony is held outside the Dagom Gaden Tensung Ling Tibetan Buddhist Monastery near Cascades Park. In the foreground is a drawing symbolizing harmony. The monastery serves the community by offering religious, cultural, and educational programs. September 2000.   WILL COUNTS

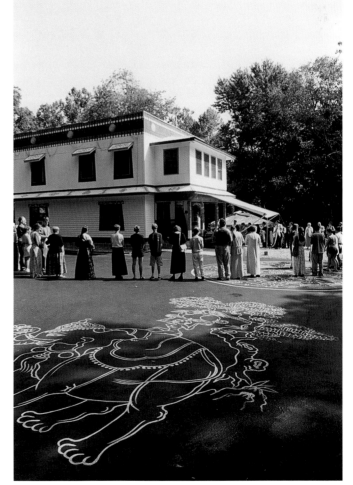

with enough machines in the gravel parking lot to outfit the Hell's Angels. At the top of the rise we turn onto the main one-way street heading south through town, College Avenue. To our left you'll see Walnut Street, the main one-way heading north, and the ribbon of green between these two streets is another city park, just wide enough to hold a meandering creek, a cluster of willows, and a remarkable limestone sculpture. Entitled *Red, Blond, Black, and Olive,* the sculpture represents two figures with faces hovering close together like friends sharing secrets. If you look closely as we roll by, you'll see that each side of each face displays the features of a different race. Commissioned by the city of Bloomington, the sculpture was placed here at our northern gateway in 1980 to symbolize our embrace of people from all nations.

I'm not going to pretend that everyone here welcomes strangers with open arms. We have our bigots, people wary of foreign ways and unfamiliar shades of skin, but they're a small and sad contingent. Most of us aspire to live in a community that reflects the bountiful range of the world's cultures. Although Bloomington's population at the beginning of the new millennium is only about 65,000, and we are far from the usual ports of entry for visitors and immigrants from other countries, you'll hear a dozen or more languages spoken on our streets; you'll encounter people wearing veils, turbans, saris, saffron robes, and dashikis; you'll find restaurants featuring cuisine from every continent except Antarctica.

We owe this richness mainly to Indiana University, which was founded here by the state legislature in 1820, only two years after Bloomington itself was officially organized. This College Avenue that we're following runs straight south to Seminary Square, where the first classroom buildings stood. Fires destroyed one of those buildings in 1854 and a second one in 1883, whereupon the university, having outgrown its original plot, bought land from the Dunn family on the east side of town, and there started over in dignified halls made of fireproof brick and stone.

We're not going as far as Seminary Square, however, because I'm anxious to get out of this car. So we pass without comment through an aisle of grand old houses that have been converted into

offices and shops, pass the courthouse square, turn left at the former Moose Lodge, and follow Fourth Street until it runs into Indiana Avenue at the edge of campus. Here we park, lace up our walking shoes, and climb out. We cross the avenue and follow a brick walkway into Dunn's Woods, a patch of venerable trees miraculously preserved in the midst of town.

This is the first place I wanted to show you in the flesh, as it were, because here you can sense what the region was like when the Shawnee, Miami, and Delaware still roamed these hills. Notice how much cooler it is in here among these great columns, how much darker, how much calmer; notice how the sounds of traffic dwindle as we move toward the heart of the woods. Lay your hands on the smooth gray bark of an old beech, or on the rough hide of a tuliptree, and you can feel the strength and stillness of the primal forest that once covered this land. I often take refuge here to smell the dirt and wet leaves, to feel the earth give under my feet, to admire ferns and wildflowers, to hear birds and cicadas and crickets. I'm grateful to all those who defended these trees from the saw, especially Herman Wells, a longtime president of the university and a visionary citizen, a man who served the community into his nineties and then passed away in the first spring of the new millennium, just as the bloodroot and trout lilies were blooming here. Sure, the woods are crisscrossed by brick trails; their darkness is punctuated at night by the glow of lamps; every quarter hour you can hear the chime of the university's clock; and in winter, beyond the bare branches, in every direction you can see the glint of windows. Yet this little scrap of woods is a reminder of where we began, and where, in spite of all our buildings and machines, we still dwell.

Let me show you two more features of Dunn's Woods before we stroll back into the streets. See how the ground appears to be dimpled, with bowl-shaped hollows here and there, some of them twenty or thirty feet across and six or ten feet deep. In summer these cavities are veiled by undergrowth, but in winter the snow reveals a pockmarked landscape, as if the ground had been cratered by small meteorites. Rain is the true culprit. These hollows are

5

formed by water carving passages through the limestone bedrock, down into underground channels, and washing soil with it. Limestone dissolves in water, slowly but surely, as you can see from the eroded statues on the courthouse square and the blurred names on grave markers in local cemeteries.

These hollows are called sinkholes, and they're one sure sign that you're in limestone country. I could lead you to places near town with as many as a thousand sinkholes per square mile. The large ones have been known to swallow cows and cars; even the small ones sometimes open into caves. The caves are another place I'll take you if we have time during your stay, and if you don't mind getting good and muddy. This porous bedrock is the reason so little water lingers on the surface here in creeks or lakes, even though we receive a goodly amount of precipitation, an average of forty-five inches per year. I show you these sinkholes to help you imagine the bones that underlie the skin of pavement and dirt.

We're leaving Dunn's Woods by a different path, so we can pause to look at this old observatory. The octagonal building is made of limestone—what else?—and the dome is covered by copper plates, like the battered shell of a turtle that has navigated all the seven seas. On the dome you can see the curving door that opens to let in the night sky. It doesn't open as often now as it did when Kirkwood Observatory was built in 1900. Back then, city lights had not yet begun to devour the darkness and hide the stars. Still, once a week or so, on clear nights, the observatory's great door opens and you can gaze up through the telescope at planets and nebulas and galaxies. I like to go there and look out on the universe and feel myself suspended between the many-million-year-old stone beneath my feet and the billion-year-old fire above my head.

Coming out of the woods, you'll want to slit your eyes against the sun. Since I can't drag you down every path in town, we're going to trace a cross-section of Bloomington along Fourth Street, beginning at the woods and ending at a cemetery, just over a mile due west of here. If you keep your eyes squinted for a couple of minutes, maybe you won't notice the parking lots that have sup-

planted the rooming houses on this first block. I'm doing my best to avoid cars on our tour, but I don't want you to think that our city has somehow escaped this modern plague.

Beyond the parking lots, we come to a delicious block of Fourth Street between Dunn and Grant, where the big frame houses on both sides have been transformed into restaurants. Smell the curry? The basil? The cumin? The oregano, dill, and thyme? The flavors change, of course, as restaurants go in and out of business, but at the beginning of the new millennium, within this one block, you can sample cuisines from Morocco, Thailand, Eritrea, China, India, Italy, and Tibet. Within a short walk from here, you could also taste Greek, Mexican, French, Yugoslavian, Cajun, Japanese, and a smorgasbord of plain old American food. If you're hungry, pick your favorite seasoning and we'll follow the smell of it indoors; otherwise, we'll head west.

The next half a dozen blocks carry us through a slice of the

Diners eat outdoors on a warm spring evening at the Siam House on Fourth Street. This section of Fourth Street features restaurants specializing in a variety of international cuisines. April 2001. CLAUDIA COUNTS

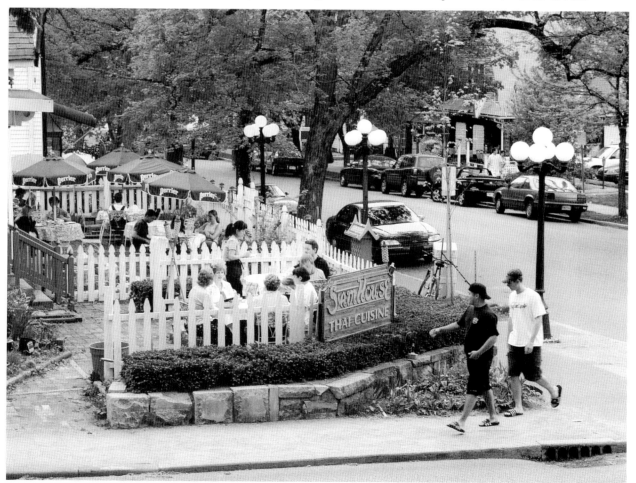

business district, which looks prosperous enough, but never fancy. If you get too fancy in Bloomington, whether in the design of your store or the cut of your clothes or even the turn of your phrases, folks will shy away. We like things plain and honest, for the most part; we avoid people and places that put on airs. So along these six blocks, in no-nonsense buildings of one and two and occasionally three stories, you can make out a will, renew your driver's license, catch a city bus, check your mail or investments, pay your gas bill, get a haircut, buy hobby supplies or second-hand furniture, listen to jazz, knock back a few stiff drinks, borrow money, or save your soul. On our left is the sandy bulk of the main fire station, with its green roof and gleaming red engines. Instead of a real dog for a mascot, the firemen have posted out front the statue of a Dalmatian, forever sitting on its haunches.

Across from the fire station and post office rises the limestone mass of First Methodist, the grandest of our churches, one known for fine music and powerful preaching. In general, as you move west from here to the far fringes of Bloomington, the preaching becomes hotter and hotter, ranging from Baptists and African Methodist Episcopalians on through various brands of evangelicals, apostolics, and Pentecostals; and as you move east from here, the preaching generally becomes cooler, ranging from Presbyterians and Episcopalians, through Catholics and Lutherans, on out to the Quakers, who keep their silence.

Continuing west into those warmer zones of Christian rhetoric, we pass a few savings and loan companies and banks, which have been proliferating here recently, with as many denominations as the churches. In fact, although Bloomington is home to a monastery, a mosque, an ashram, and a synagogue, as well as a bevy of churches, I suspect we now have more banks and brokerage firms than houses of worship—which may reveal something about our true religion.

My favorite building on this stretch of Fourth Street is the former city hall, which became the police station, which then became a community arts center. You can attend plays or concerts or literary readings upstairs in the auditorium; you can survey new

art in the ground-floor gallery; in the basement you can paint canvases or throw pots. If you look in through these lower windows as we stroll by, you're likely to see children or grownups working away, surrounded by their latest productions drying on easels or shelves. The Waldron Arts Center is one token of a vibrant community, a blessing created through the efforts of many people. A block from here, I will show you the Buskirk-Chumley Theater, a former cinema that was closed by its out-of-town owners, was then acquired and thoroughly renovated by a citizens' group, and reopened as a center for the performing arts. If time permits, I'll also show you the old Carnegie Library, which has been converted into a historical museum; and I'll show you the new library, which was recently expanded to cover a square block, with room enough to hold meetings, lectures, and slide shows, as well as books. If a city is going to be a community and not merely a collection of people chasing separate dreams, then it needs such gathering places, where citizens can share visions and stories.

Beyond the arts center, just over the railroad tracks, this blank slab of pavement on our right has been donated by the city for the construction of WonderLab, a science museum for kids. Even with volunteer labor from hundreds of people, the project will still cost nearly four million dollars. How long it will take a city of our size to raise the needed funds is anybody's guess, but I believe the money will come, and on some future visit you'll be able to step inside a finished museum and behold the glow of discovery on faces of all ages. Again, we can trace much of the energy behind WonderLab to the university, with its wealth of scientists and laboratories, but energy also comes from countless people outside the university, who cherish curiosity and reasoned inquiry.

It's fitting that such a venture into Bloomington's future should locate here beside the tracks, because the railroad figured prominently in the city's past. If we followed the rails south, we would pass the sites of limestone mills and quarries and a plant that made color televisions; and if we followed the tracks north, we would pass the sites of foundries, tanneries, salvage yards, warehouses, a creamery, a furniture factory, and a semiconductor plant—most

of them now converted to other uses, but all of them influential in shaping the town. Owners of the factories and mills, for example, often built grand houses of stone or brick near the tracks, where they could keep their eyes on business, while many of their employees built modest frame cottages on the hills to the west. If you walk the crossties through town, as I sometimes do, you can see written in the buildings themselves the shift from an agricultural and manufacturing economy to a new economy based on financial services, information processing, education, and electronics. I'll spare you that walk, because we still have a few more blocks of Fourth Street to cover.

*C*rossing Rogers, we soon leave business behind and enter a neighborhood of big shade trees, small yards packed with flowers, and lovingly restored wooden houses painted every shade of the rainbow. Amid fretwork in the gables, here and there a date has been carved, usually around 1900. Back then, Bloomington was enjoying a flush of prosperity, mainly from selling products fashioned out of iron, wood, and stone. Men who wrestled with those materials also built many of these houses, and their skill shows in the tight joints, clean trim, and sturdy lines. If the builders were to come back and see their handiwork, I think they would be proud. Unlike the chilly castles rising now in our suburbs, standing far apart in bland expanses of chemically treated grass, these cottages and bungalows nestle close to one another and close to the street, inviting visitors. Don't the wide porches make you want to climb the front steps and sit for a while in a rocker or swing? The sidewalks are thronged with kids, and the air is thronged with birds. Listen, and you'll hear laughter and talk, the sound of a hammer striking nails or a shovel striking dirt, the run of scales on a cello or guitar, the rattling of a spoon in a bowl.

Although these few blocks on West Fourth are unusually well preserved and appealing, there are fine old neighborhoods like this scattered around the city. I could show you Prospect Hill, Vinegar Hill, Elm Heights, or the cluster of Victorian painted ladies on North Washington, just to name a few examples. These neighborhoods

date from before the triumph of automobiles, when we still used our bodies to get around, and before the triumph of television, when we still made our own entertainment, and before air conditioning sealed up our houses like tombs. They speak of the city as a place where people gather not merely for the exchange of goods and services but for the pleasure of one another's company.

Now we can proceed to our final stop on Fourth Street—and the final stop for many Bloomington citizens—Rose Hill Cemetery. I'm not sure where the "rose" comes from, but you can feel the hill by the strain in your legs as we climb. Those white pines up there spreading their shaggy branches against the sky show how far we have to go, for they stand near the top of the rise. To our left as we enter are the oldest markers, those small stubs of limestone and marble, their names and dates all but scrubbed away by a century of rain. To our right are the more recent gravestones, which are mostly granite, and are therefore durable enough to reveal dates from the 1880s or so to the present year. You could match the names from many of our city's principal streets, buildings, and businesses with names on these gravestones: Showers, Faris, Buskirk, Woolery, Allen, Rogers, Hinkle, Griffy, Wylie.

The monuments capture the range of our allegiances. You'll find limestone carvings of trees with limbs lopped off to show how many children were left behind; you'll find sculptures of lambs, eagles, and doves; you'll find a marble angel holding a wreath a few feet away from a bronze infantryman lunging with a rifle. Measured by size and location, the war memorials win out over the religious ones. The tallest monument of all, on the highest point in Rose Hill Cemetery, is topped by a Union soldier who casts a melancholy gaze at the circle of headstones below, recalling those who died in the Civil War.

There's usually a good breeze up here, which brings the sound of barking dogs, fussing crows, and growling machinery. In summer, goldfinches zip overhead with their roller-coaster flight and their sewing-machine call. Spring and fall, warblers stop through on their migrations and fill the maples with chatter. Looking west from the foot of the Union soldier, you can make out plumes of

dust from bulldozers gouging new roads, can see a lumber yard and a gravel yard, can trace power lines dipping and rising from pylon to pylon, can sense the muscular push of the city out over the countryside.

How large Bloomington can grow without smothering the grace and spirit that have made it such a good place to live is a question that troubles many of us—but not, apparently, those who stand to profit from sprawl. If I were to blindfold you and set you down on the outskirts of town and uncover your eyes, only the trees on the horizon and the color of the sky would reveal that you weren't on the fringes of Buffalo, say, or Phoenix, or Sacramento. You would see out there the usual shopping malls, strip malls, plazas, motels, multi-screen cinemas, discount warehouses, burger joints, pizza parlors, speedy-marts, and other cookie-cutter franchises. I'm keeping you downtown so you'll feel that you've actually come to someplace different from the place you left.

So now we'll turn around and head back east toward the courthouse square, which is still, remarkably, the heart of town. As much of the way as possible, we'll go through alleys. I want you to see the sides of houses hidden from the street, the cramped yards filled with hammocks, tarp-covered boats, and jalopies up on blocks; the pocket gardens stuffed with tomato plants, sunflowers, and herbs; the lawns crammed with ornaments, clotheslines, swing sets, doghouses, playhouses, tree forts, and sheds. A few of the garages once were stables, and the more rickety of them now appear to be held together only by the ivy growing up their walls. Some alleys are paved with brick, some with lumpy blacktop, most with coarse gravel that can turn your ankle if you don't watch out.

I doubt that anybody will look askance at us as we amble past their back doors. By and large it's a trusting town, a safe town. There are no snarling attack dogs, no gates with guards, no security fences, no bars on ground-floor windows. Many people leave their houses and cars unlocked. Many people, including some solitary women, walk the streets at all hours of the day or night. Children play outside. The elderly people I know tell me they move about the city

with no fear of being mugged. On the other hand, in recent years we've had a few assaults, abductions, and murders, every one of them featured in the newspaper for weeks or months. Because guns are so easy to get, quarrels that formerly would have led to fisticuffs now sometimes lead to shootings. The police warn us that gangs may be lured here from Indianapolis or Chicago by the prospect of making money on drugs, and a few suspects have been arrested, but so far we've mainly seen a rash of graffiti. Still fairly safe, still trusting, as you can see by these vulnerable back yards, Bloomington could sacrifice those qualities by pursuing unlimited wealth and growth, or it could preserve them by pursuing the goals of community and justice.

We've come to the town square, with its imposing courthouse, one symbol of the search for justice. The dime stores and hardware stores and department stores that once lined the square have given way to cafés, gift shops, an adventure outfitter, a paint store, a pool hall, a frame shop and photography studio, an ad agency, an Oriental rug shop, and a bead shop, as well as stores devoted to sporting goods, clothing, and games. One small grocery holds on, along with two furniture dealers and three bookstores. You may not be able to buy all the necessities of life down here, but you can savor many of life's pleasures, and you can do so in well-kept surroundings. Many of these buildings have been renovated, especially on the south side of the square, and all are open for business, a rarity for downtowns in the Midwest.

The key to this vitality is the limestone courthouse itself, rising in neoclassical grandeur here at the center of town, complete with statuary and columns, elaborately carved ornaments, and a dome the color of turquoise. If you look closely, you'll see on top of the dome a weathervane in the shape of a fish, the work of the town's first blacksmith, dating from the 1820s. You might be wondering what a fish is doing on the peak of a courthouse in this landlocked town, so far from any coast. I can't say what the city fathers and mothers had in mind when they put it there, but what I think of when I see that fish is the ocean that once covered the interior of the country. Remember the limestone beneath our feet, formed at

the bottom of an inland sea. True, the salty waters dried up some hundred million years ago, when the heartland was lifted above sea level by the rising of the Appalachian Mountains, but that's not long at all in the lifetime of a planet or star. I like to think our fish is keeping vigil until the waters come back. Geologists call that vanished ocean the Sundance Sea—a name that might still apply to this light-washed, green, and billowing country.

Inside the courthouse we can examine the rotunda, the stained glass windows, the sweeping staircases and balustrades, all of it meticulously restored. This building is crucial to the identity of Bloomington not so much because of age—it will be only a century old in 2008—or architectural distinction, as because it pays tribute to our local stone and to the craftsmen who worked that stone with so much skill. It also embodies our belief in the necessity of government and the rule of law. The restoration of the courthouse in the 1980s inspired further renovation on the square and

Late afternoon traffic passes the Monroe County Courthouse. In 1980, the county considered whether to replace the 1908 limestone structure. The community rallied around a proposal to keep the courthouse, renovate it, and work to restore the surrounding square as the focus of the community. 2001.
WILL COUNTS

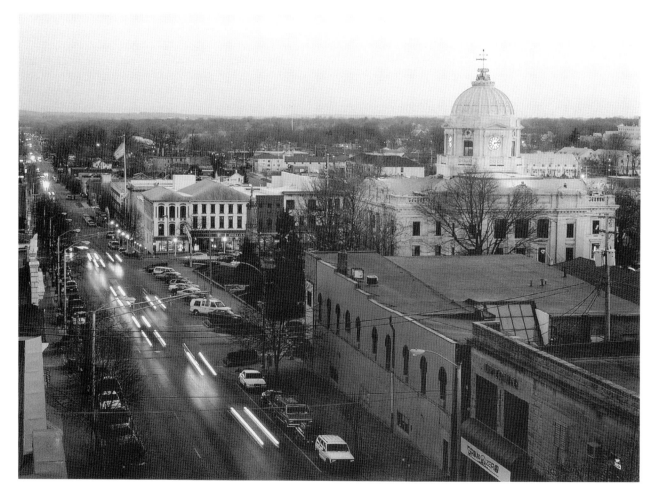

on other blocks nearby, and that renaissance drew businesses and residents back to the heart of town. Seeing the activity here today, it's important to realize that just two decades ago the courthouse came within a single vote of being torn down, in favor of a steel-and-glass box that no doubt would have been more efficient but would have had nothing to do with our history or location.

*I* mention this close vote over the fate of the old courthouse as a reminder that our city is precariously balanced between forces that weave the fabric of community and those that unravel it. I haven't shown you many of the unraveling influences because they would already be familiar to you from your travels—sprawl, congestion, rabid consumerism, the breakdown of families, the gulf between rich and poor, the erosion of local culture by global media, the tyranny of transnational corporations that create and abolish jobs at the whim of distant financiers. Instead, I've tried to show you a few of those influences that draw us together, nurture our best qualities, remind us of our ties to one another and to the land— the company of trees and stones, the open space of parks, the yards overflowing with plants and birds, the array of foods and manners and people from around the world, the museums and libraries, the centers for art and music and dance, the neighborhoods of restored houses with their welcoming porches, the locally owned businesses, and the walkable streets.

If you're willing to stay awhile, I could show you other spots where the fabric of community is being woven. I could show you schools where teachers work hard to engage parents in the education of their children. I could show you public gardens and public art. I could take you to concerts in the parks, to crafts festivals on the square, to fireworks at the stadium. We could go shopping for organic produce at Bloomingfoods or for ethnic delicacies at Sahara Mart. We could volunteer at the women's shelter or the soup kitchen or any of the dozens of places in town where people give their time to help those in need. We could sample the compact discs produced by local musicians and the books produced by local writers. We could enjoy a play, an opera, or a ballet at the uni-

versity, or go hear a visiting lecturer speak on subjects ranging from the origins of the universe to the Dead Sea scrolls.

With enough time, we could count a great many blessings that make me grateful to live in this place. For today, however, before I wear you out completely, let me show you one more vital spot. We have only a short walk, because what I want you to see is the Showers Building, a few blocks west of the square. Constructed as a furniture factory around 1860, just in time to make coffins for the Civil War, this huge, handsome brick building is known to everyone in town by its saw-toothed roof line, the vertical strokes facing north to admit light through clerestory windows. After the factory closed, the space became a warehouse, and over the years it grew shabby from neglect—so shabby, in fact, that like the courthouse it almost succumbed to the wrecking ball. But again, people stood up to defend this landmark. A partnership was formed among the city, the university, and the private sector to renovate the building, and today Showers is home to government offices, law offices, restaurants, and high-tech enterprises. Inside, we can watch the city council debate the common good or talk with officials about the needs of our neighborhood. Outside, we can stroll through the terraced garden or dabble our fingers in water pouring from a fountain down a serpentine channel, so reminiscent of our meandering rivers.

We may have to compete for space at the fountain with children, especially on Saturdays when the farmers' market fills the Showers parking lot. If you happen to visit between the last frost in spring and the first one in autumn, you must linger here over a Saturday, so we can walk among the market stalls, relishing the heaps of corn, the fragrant cantaloupes, gourds the size of bushel baskets, eggplants like giant purple tears, and beeswax candles smelling of meadows. Whatever fruit or vegetable your heart desires, from apples to zucchinis, we can gather here. We can take home a bouquet of gladiolas, poppies, phlox, lotus blossoms— whole gardens of flowers. We can listen to musicians playing reggae, rock-and-roll, classical, or Afro-pop. We can sign petitions, if we wish, register to vote, question political candidates, or volunteer to

work for a local cause. We can watch flocks of people, all ages and varieties, idling by the stalls, filling their bags and arms with bounty. They talk, touch, greet friends, dandle babies, exchange notes and promises; they shelter from the rain under pavilions or tilt their faces to the sun. In those faces we can read the pleasure that draws humans together into villages and cities, the delight in sharing words, food, beauty, and laughter.

Let's indulge in that delight by going to my house for a meal and conversation. We'll reclaim the car, drive a mile or so, then go inside and take off our shoes. Ruth will be expecting us, although she can never be sure when her wandering husband will show up. A few friends will be coming over later to meet you, and you can ask them, as you've asked me, what holds a person here in Bloomington. I don't imagine that our brisk tour will fully explain why I'm devoted to this place; nor do I expect you to love my town merely because I do. I only hope that you love *some* place, some particular city or neighborhood or plot of ground, where you know the smells and sounds and sights, where your feet know the contours of the land, where you feel moved to speak up for what you cherish.

Milburn Weber, 88, shows off the produce and flowers he is selling at the Bloomington Community Farmers' Market at Showers Common. Weber says that everything he sells comes from his garden at his home west of Bloomington. August 12, 2000.   WILL COUNTS

*James H. Madison*

# Old Times and New Times in Bloomington

All communities build on the past. All mix ingredients of tradition and change in combinations that vary across time. Bloomington's community chefs at the beginning of the twentieth century cooked mostly from recipes of tradition. By the start of the twenty-first century, there were more chefs cooking, more varieties of dishes, more change and less tradition.

## THE PIONEERS

Bloomington of the nineteenth century, and well into the twentieth, was a community more like than unlike neighboring towns, particularly the county seats of southern Indiana. All were settled by pioneers moving in a massive stream of migration from the Upland South of western Carolina, the valley of Virginia, eastern Tennessee, and Kentucky. Joining these Upland Southerners were folks from Pennsylvania and New York, plus a sprinkling from New England. But the Upland Southerners dominated.

Southern Indiana pioneers were a people of corn and hogs, of Bibles and hard work, of family and home. Some of these first Hoosiers, such as their greatest exemplar, young Abe Lincoln, were full of imagination and hunger for learning; others were content with the old ways of their forebears and reluctant to spend a single penny on taxes, schools, or books. Nearly all prized their individual freedom, their conviction that white men, at least, were all equal and that no man should lord over them. In Bloomington beginning in 1818, as across southern Indiana, they created a pioneer democracy.

The Bloomington of these nineteenth-century pioneers was a small town of limited horizons hampered by inadequate transportation (there was no navigable river) and an anemic economy and water supply. It was not a static community, however. The founding of Indiana University in 1820 had some small impact on the town, even though the institution struggled for decades to survive. Another significant change came in 1854, when the New Albany and Salem Railroad ran its tracks west of the courthouse square. Eventually known as the Monon, and connecting north to Chicago, the iron road was Bloomington's critical link to the outside world for limestone, furniture, and college students.

During the late nineteenth century, several important changes prepared a foundation for growth: the limestone industry began to take off; the small university moved to Dunn Woods on the east side of town in 1884 following a fire at the campus on South College; and David Starr Jordan arrived to begin his career as an energetic and far-sighted university president. About the same time, a fire at Showers Brothers Furniture caused the growing factory to move from the east to the west side, closer to the railroad tracks. The west side became increasingly industrial, the east side more residential, and by the turn of the century Bloomington was enjoying moderate growth as its promoters looked hopefully to the future. When the census bureau in 1910 decided that Bloomington was the center of the nation's population, it seemed to the town's boosters only right.

At the beginning of the twentieth century, Bloomington was still more similar to than different from such nearby towns as Bedford, Columbus, and Salem. The presence of the university made an obvious difference, but that institution's mark on the community was still not large enough to shape it dramatically.

Like many other small towns in southern Indiana and across the Midwest, Bloomington in the first decades of the century saw more unfulfilled expectations than heady growth. The town lacked the advantage of location in a rich agricultural district. Local farmers found the going especially tough by the 1920s and 1930s, as they struggled to grow enough corn, wheat, and hogs to support their families. Monroe County's hilly and unglaciated land was eroded and unsuited to modern agriculture. Local farmers were considerably poorer than their counterparts in other areas of the state and the nation, and they increasingly had to find work in town. For decades they lived in transition between farm and town and between plow and factory, as they sought to enjoy the benefits of both worlds.

Bloomington struggled in the early twentieth century because it attracted few industries. Showers Brothers was the great exception. Founded around the time of the Civil War, by the 1920s it claimed to be the world's largest furniture company. In its huge building with the saw-toothed roof just to the northwest of the square, the company produced kitchen cabinets, bedroom and dining room suites, and other furniture. Showers was by far the town's largest employer, with about 1,500 workers during the 1920s. The company's paternalism offered workers good job security, along with very low turnover, health insurance, entertainment in the company auditorium, sponsorship of athletic teams, an orchestra, and a Boy Scout troop. The company's newsletter, *Shop Notes,* provided morale-building advice and commentary aimed at creating a family feeling within the company. Labor union efforts to organize workers at Showers withered. The Depression of the 1930s hit the company hard, so that the factory was often shut down for weeks

JAMES H. MADISON

21

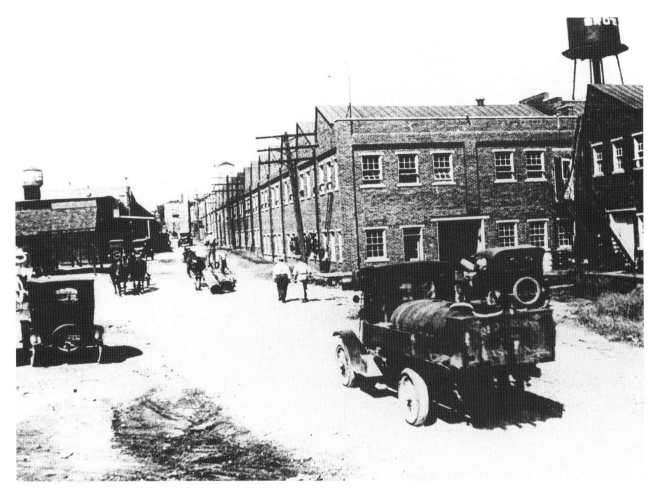

The unique saw-toothed roof of the Showers Brothers furniture company is evident in this historic photo. Founded in 1868, Showers was Bloomington's largest employer in the 1920s. The building now houses government offices and other businesses.
MONROE COUNTY HISTORICAL
SOCIETY MUSEUM

and even months at a time. The business recovered somewhat in the 1940s, but it never again reached the levels of the 1920s, and it faded away in the 1950s. Left behind were some of the magnificent buildings, which at the end of the century were adapted as the home of city government and several businesses.

Limestone was the other major industry of the early twentieth century. Quarries and mills dotted the area and provided cut stone for the national building boom of the 1920s, and for some of Bloomington's most beautiful homes and public buildings. During these peak years, the industry employed some 2,000 workers in the Bloomington area. But the Great Depression combined with changing tastes in building materials to bring disaster. As with furniture, limestone recovered somewhat after World War II, but never again reached the employment levels of the 1920s. These two major industries depended on natural resources of stone and wood and on hard physical labor. By mid-century they were not Bloomington's future.

Bloomington did not attract auto factories or other of the more profitable industries that spurred growth in some Midwest towns. Transportation was one handicap. The Monon Railroad and a spur of the Illinois Central reached the town, but none of the great east–west trunk lines did. Highways were poor. And there was the problem of water for drinking and fire protection. Lack of water was a weakness that for decades threatened the community. Among the most negative aspects of Bloomington's history is that the town struggled so hard and so long to provide water in sufficient quantity and quality.

## WATER

*N*atural springs had supplied water to pioneers, supplemented in the late nineteenth century by cisterns and public wells dug near the square. By 1900 this supply was inadequate in quantity to fight fires, and inadequate in quality to avoid diseases such as typhoid fever. During dry spells the problem became so serious that members of the state legislature began to urge that the university be moved. The construction of Griffy Lake in 1924, over Mayor John Harris's strong opposition, seemed to offer a solution. But population growth (a near doubling between 1920 and 1940) and a drought in the late 1940s again revealed a water shortage. In the early 1950s the city began construction of a reservoir on Bean Blossom Creek several miles east of town, eventually named Lake Lemon in honor of Mayor Tom Lemon. The dedication in 1953 included a seventeen-gun artillery salute and predictions of rapid industrial growth with abundant water. Lake Lemon also provided recreation at the university's Beechwood Heights and the city's Riddle Point Park. The new lake was a major factor in Bloomington's selection as an All-American city in 1959.

Lake Lemon brought hopes that the water problem was solved, some said for a hundred years, but within a decade the old nemesis was again on the horizon. By the mid-1960s periodic water restrictions returned. But this time outside help arrived in the form of

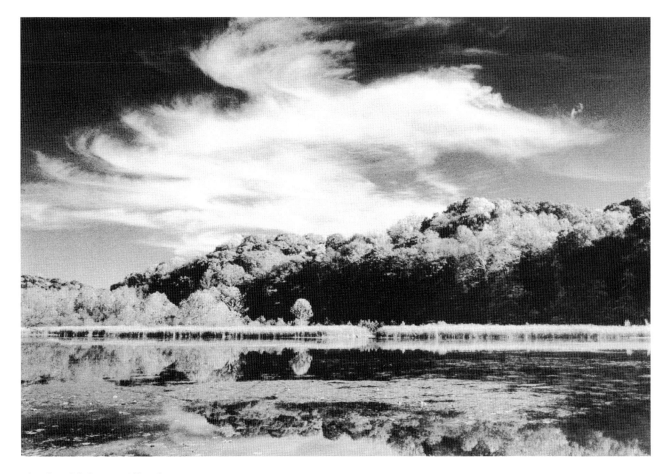

Clouds swirl above Griffy Lake, a nature preserve on the north side of Bloomington. The lake served as a reservoir for the city's drinking water from the 1920s into the 1960s. Fall 2000.
ROGER PFINGSTON

Lake Monroe, built by the federal and state governments. Dedicated in 1964, Indiana's largest lake provided not only abundant water for Bloomington, but flood control and recreation as well. Lake Monroe would not last forever either, some said. By the early twenty-first century, there were concerns about erosion and pollution of the watershed as Bloomington expanded southeastward and as boats and people fouled the water. Similar problems, exacerbated by leaks, troubled Lake Lemon.

Related to the water problem was sewage treatment. During the nineteenth century there was none, resulting in contaminated wells and springs. The new century saw the town's first settling tanks and sewer pipes. It was a difficult problem, exacerbated by the limestone bedrock and the "hump" that rose at Eleventh Street over which sewage would have to be pumped. A treatment plant built in 1935 was soon grossly inadequate, which meant that sewage was being discharged directly into Clear Creek. Some residents had septic tanks, but forty percent of Bloomington homes in 1940

did not have flush toilets and relied instead on backyard outhouses. A study in 1949 claimed that the city's sewage facilities were the worst in the state.

The challenges of water and sewer were among the most important of the twentieth century. The pioneers' attachment to small government, low taxes, and individual responsibility meant that twentieth-century citizens came very close to disaster. On this critical issue of water, Bloomington faced only the first of many challenges of growth and development. No citizen with a sense of the town's history would predict that these challenges will go away in the twenty-first century.

## RACE

$\mathcal{T}$raditions of the nineteenth century persisted also with unhappy consequences in matters of race. Many white pioneers brought with them an antagonism toward African Americans that produced segregation and discrimination well into the twentieth century. Bloomington's black population remained small, counted in 1920 at only 479 people of the total 11,595 residents. Many African American families lived on the east side of town, where their children attended the "colored school" at Sixth and Washington Streets. As property values rose near the university, blacks moved west, and the "colored school" was torn down in 1915 to make way for the new Carnegie Library. A separate three-room elementary school for black students, Banneker School, opened on the west side in 1916. All the black kids in town in grades one through eight went there. This segregated school did not close until 1954. Although black students attended Bloomington High School, there were no African American teachers hired there until the 1960s.

A survey in 1946 by an IU graduate student, Hortense Holloway, reported that the city swimming pool was closed to blacks, and that of the four movie theaters in town, two allowed blacks in the balcony section only and one barred them entirely. Many restaurants and bars refused to serve them. Holloway's survey showed

that most African Americans worked as unskilled laborers and as servants and maids. Showers hired a few black men, as did the Monon Railroad Shop. There were a few black-owned businesses in 1946: one shoe shop, two barbershops, one beauty shop, one restaurant, and one grocery store. Four ministers and two teachers constituted the professional community.

Two churches on North Rogers Street were the center of religious and social life for most African Americans—Second Baptist, built in 1913, and Bethel AME. The cornerstone of the latter was placed in 1922, and money for construction was raised in part by Mattie Jacobs Fuller, who on Saturday afternoons played a portable organ and sang on the courthouse square. According to the book *A Time to Speak,* by Frances Gilliam, Mrs. Fuller raised more than $13,000 for the AME church. There were also African American social clubs and lodges, Boy Scout and Girl Scout troops, family reunions, and informal social gatherings.

Indiana University did not seriously challenge racial discrimination in the early twentieth century. Black students had to live and eat in black homes or boarding houses. There were no African American basketball players until Bill Garrett came in 1948, and there were none on the team that won the NCAA championship in 1953. Long remembered was the abduction of Halson Eagleson, Jr. In a 1922 prank that had racist origins, several white IU students kidnapped the young black student. His family, one of Bloomington's most talented, was outraged and brought suit, despite strong pressure from local whites to drop the matter. The legal system provided no remedy, and not until 1982 did the university make symbolic amends to Eagleson and his family.

As in most American small towns of the early twentieth century, a white Protestant majority led in Bloomington. Many were unable to see the full humanity of blacks, Jews, foreigners, or Catholics. The prejudices so old in America burst forth most hotly in the early 1920s when the Ku Klux Klan came to the Midwest and to Bloomington. Based in the Protestant churches, the KKK attempted to enforce its brand of morality, religion, and patriotism against prohibition violators, adulterers, and others who strayed from the

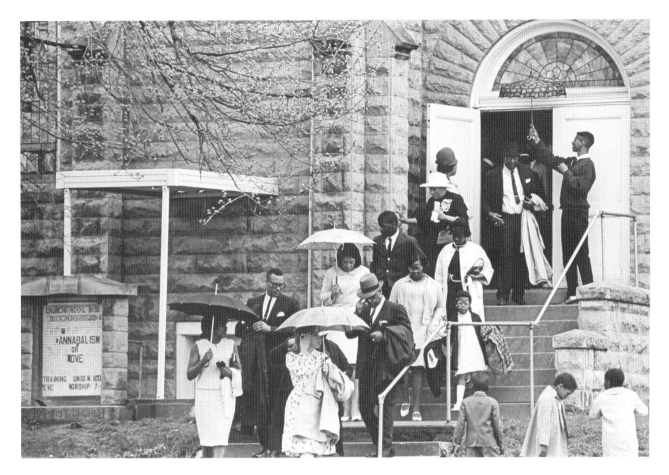

organization's narrow code. In November 1922, 125 robed Klansmen marched to the square; another large gathering occurred there on May 23, 1923. The organization claimed 1,589 members in Monroe County in 1925 as it operated from its headquarters at 213 North College Avenue. There was no real Klan violence, but intimidation cast a fear over the community that was remembered for decades even though the organization declined rapidly after 1926.

Worshippers leave the Second Baptist Church on North Rogers Street. The church, built in 1913, has long been an anchor for Bloomington's African American community. 1966.
DAVE REPP

## SMALL-TOWN JOYS

*N*ot all was bleak in Bloomington. The Roaring Twenties brought a new movie house, the Indiana Theater on Kirkwood Avenue, with its glitzy lobby of chandeliers, marble, and mirrors. Just a few years earlier the Book Nook on Indiana Avenue had emerged as the student gathering place for food, conversation, and music, some of it played and composed by hometown boy Hoagy

Carmichael. Watchful moralists claimed that IU students at the Book Nook and elsewhere were falling to the temptations of bootleg alcohol. There were, however, better and more abundant opportunities for sin in all forms in the saloon district just west of the square and along the railroad tracks, an area known as "the Levee."

There were less "jazzy" forms of recreation, too. Young and old alike could enjoy a chocolate soda at Wiles Drug Store on the square. The city park on Third Street, between Washington and Lincoln, provided a swimming pool, a band shell with concerts each Thursday evening in summer, and union church services on Sunday evenings. Cascades Park, north of the city, offered picnic grounds, a swimming pool, and a golf course.

There were clubs and social organizations, too, as many as 400 in 1940, devoted to music, books, play reading, and church activities. Associated with the churches were various youth and women's organizations, as much social as religious. The Methodist Epworth League was especially popular among teenagers. Men gathered in Rotary and in fraternal lodges. In the mid-1920s the Masons built a three-story temple on Seventh Street. An especially important organization was the Bloomington Council of Federated Church Women, later called Church Women United, an ecumenical movement that began in the 1930s and led to the establishment of the Christian Center and a nursery school on West Eleventh Street.

Sports became increasingly popular as recreation and entertainment, especially for men and boys. Basketball was always played and was the topic of conversation from Thanksgiving into March. Baseball and softball were popular, too, with factory and community teams. Burnett's Bowling Alley offered amusement in winter months. And there was golf at Cascades and the Country Club. Beginning in 1936, there was the Soap Box Derby.

Simple pastimes remained popular in the early twentieth century. The list was long: hunting mushrooms on cool spring days; swimming in the quarry holes on hot summer days; sitting on front porch swings and talking; gathering on the courthouse square on Saturdays; shopping and visiting with friends; placing flowers on the graves of loved ones on Decoration Day; tasting the different

pies at large family reunions each August; buying a new suit at Kahn's on the square for Easter Sunday; hearing the IU Chorus sing the *Messiah* each December. Bloomington newspapers in these years were filled with local news, such as the report of July 4, 1926, that "Mr. and Mrs. Charles Gilham have returned from a visit with relatives at Bicknell."

Bloomington as late as 1940 was little different from other county seats of the Midwest generally, and southern Indiana in particular. It was the sort of place that newcomers to the university sometimes disdained as provincial and poor. One of the most scornful was Maie Clements Perley, a faculty wife. Her 1940 book *Without My Gloves* described her first sight of the town and its limestone courthouse, as "black as the ace of spades, begrimed and mildewed." And sitting on its steps were men of all ages, "huddled and slovenly" and "looking spineless and aimless except for their continual spitting." The place was "as dead as ash," Mrs. Perley grimly concluded; it was "Bloomington—Doomington" for this sophisticated and lonely woman.

Maie Perley was not the last faculty wife (and nearly all faculty spouses in those days were wives) to find Bloomington so small and backward. But change came, gradually in the 1940s and 1950s and more quickly by the 1960s and 1970s. By the end of the century there would still be newcomers unhappy because Bloomington was not New York or Paris, but there were many more who came to understand what it had become and approved.

## BOOM TIMES

$\mathcal{T}$he changes that would make the Bloomington of the twenty-first century appeared first in the economy and the university in the 1940s. Both began to grow in a long stretch of prosperity that continued into the 1960s.

For many in Bloomington, the Great Depression ended on February 22, 1940, when they learned that the Radio Corporation of America had purchased one of the Showers plants for a new fac-

tory. The Bloomington *Telephone* exulted: "It appears almost too good to believe that a great corporation has brought a new factory to Bloomington and will give excellent jobs to several hundred women and a fewer number of men." RCA's first Nipper radio rolled off the assembly line in June 1940. By 1942 the company employed 1,200 workers, and the city government had printed its official stationery to read: "Bloomington, in the Heart of the Famous Oolitic Stone Belt, is the Home of Indiana University, the world's Largest Furniture Factory and RCA Manufacturing Company."

The arrival of RCA was a major shift in at least two ways. First, the company represented a transition from the old natural resource–based and low-technology industries of limestone and furniture—industries in decline—to a more modern and technologically sophisticated production that could flourish amid American affluence of the 1950s and 1960s. There would be profits and jobs in radio, and later television, manufacturing that were no longer possible in limestone or furniture.

RCA represented a shift also because it employed large numbers of women at a time when women's work outside the home was limited largely to clerical, service, and domestic jobs. In 1940, 310 of the 444 first employees were women. Most were young, single high-school graduates. Indeed, the company set an age limit of 18 to 30 for women workers, presumably because managers considered them more dexterous and "trainable" for the kind of assembly-line work that was required. Most of the work that women did at RCA was tedious assembly-line crimping and soldering, and the sexual division of labor created two wage scales, with women's pay lower than men's. Still, many young women eagerly sought work at RCA: the pay was better than elsewhere, and the sense of independence and of community with other women workers was important. Pulling profit-seeking RCA executives westward, as they abandoned their old plant in Camden, New Jersey, were a lower wage scale and more malleable workers, unmarked by union traditions.

World War II brought conversion at RCA and other Bloomington plants. RCA made electronic proximity fuses and

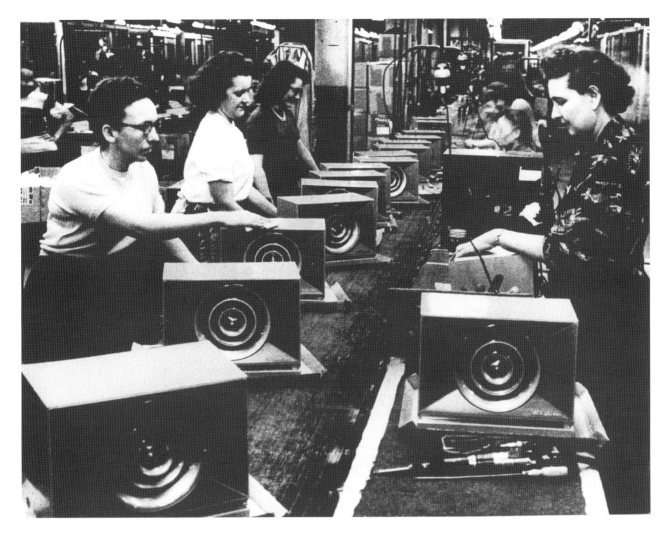

radios for tanks; Showers made truck body parts. Bloomington provided soldiers and sailors as well as defense workers for the fight against the Axis. The small plaque on the south side of the courthouse lists the names of the 172 Monroe Countians who died in the war. One who came back was the town's greatest hero, Gerry Kisters, winner of the Medal of Honor.

Peace brought rapid reconversion to consumer products. In 1949 RCA made its first television set, followed five years later by the first color set. By this time the company employed 3,000 workers, and Bloomington claimed title as the world headquarters of television manufacturing.

Other factories sprouted up in Bloomington during the 1950s and 1960s, particularly after Lake Lemon seemed to quiet fears about water. Sarkes Tarzian was an immigrant from Armenia who

arrived in town as an engineer with RCA and soon went into business on his own. Pioneers in television technology, he and his wife, Mary, opened a large factory on Hillside Drive in 1953 that employed as many as 2,000 people. To the east of the factory they built one of Bloomington's largest homes, surrounded by sixty acres of rolling, open land that in 2000 became half apartment complex and half nature conservancy in the middle of the growing city. Westinghouse, General Electric, Otis Elevator, and other manufacturers settled west of the city limits, lured by government and business leaders.

Bloomington's industrial boom lasted into the 1970s but then sputtered. Most ominously, RCA withered. Its workers became more assertive, and in the years 1964–1967 they went on strike three times—"a sea-change in Bloomington's working class life," historian Jefferson Cowie concluded in a book about RCA titled *Capital Moves.* Gradually, beginning in 1968, the company moved production from Bloomington to Ciudad Juarez, Mexico. Lower-paid foreign labor and new machines replaced, first, low-skilled and labor-intensive work in Bloomington, and then higher-skilled labor. Sale to a French company, Thomson, did not change the descent; nor did tax advantages provided by the city. In the spring of 1997, RCA announced that the last 1,100 jobs would soon go. Tarzian had earlier followed a similar path, announcing the closing of the Hillside plant in 1977. Bloomington could no longer claim to be the television capital of the world. Westinghouse sold out in 1989 (leaving behind streams and dumps contaminated with toxic PCBs). At the beginning of the new century, General Electric, Otis, and other factories were moving in similar directions as global competition and changing technologies caused de-industrialization. Left behind were empty factories and older workers struggling to find good jobs.

At century's end, among the companies that seemed to represent the future was Cook, Inc. Bill and Gayle Cook began making medical instruments in 1963 in a second bedroom of their Bloomington apartment. Cook pioneered in high-technology manufacturing, and by the late 1990s the company's various enterprises

were second only to the university in local employment. The Cooks were among the nation's wealthiest families, enabling them to make numerous contributions to the community's quality of life. There were several other smaller, sophisticated businesses operating at the beginning of the twenty-first century, but Bloomington had not yet become the high-tech center that many hoped for.

The ups and downs of manufacturing were ameliorated by the growth of the university. Students burst onto the campus at the end of World War II. By 1948 there were 2,100 IU employees, almost three times as many as in 1940. And there were new jobs in town. The coming of the baby boomers in the 1960s only added to IU's importance in the local economy. From the dozens of pizza shops to the construction of new dormitories and apartments, there was no denying the economic impact of the university. Even though manufacturing jobs had declined, unemployment in Bloomington in the 1980s and 1990s remained low.

## DOWNTOWN AND SUBURBS

As the population expanded from 20,000 in 1940 to more than 66,000 in 2000, the shape of Bloomington changed. At the end of World War II, the courthouse square was still the center of town, surrounded by Wicks Department Store, the Graham Hotel, J.C. Penney's, Bloomington Hardware, the Princess and Indiana movie theaters, the Faris Brothers Market, and numerous other businesses. Business and professional offices began to expand east along Kirkwood and north along Walnut and College. In the late 1940s, the city installed 306 parking meters downtown and boasted of nine traffic lights, most around or near the square.

The coming of the College Mall in 1965 threatened to leave a hole in Bloomington's center. When Bloomington Hardware moved from the courthouse square to the mall area in 1985, some thought the town was ruined forever. But the downtown continued to offer shops and restaurants—many locally owned—and remained a gathering place for entertainment, celebration, and protest, or a

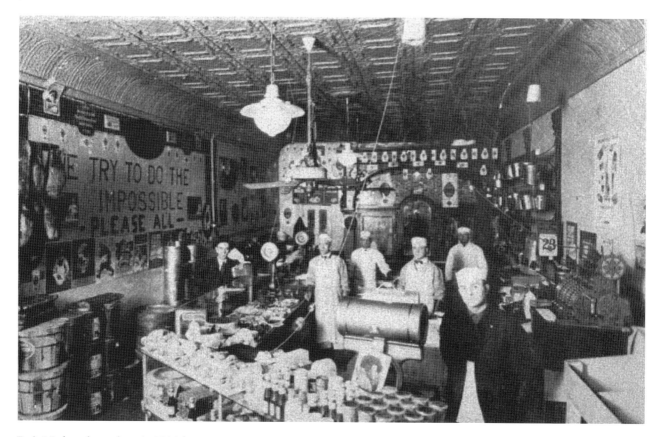

Faris Market, shown here in 1916, is Bloomington's oldest downtown food store. It was owned by the Hinkle family (who founded Hinkle's Hamburgers, one of the city's oldest restaurants) before being purchased by the Farises in 1923.
MONROE COUNTY HISTORICAL
SOCIETY MUSEUM

great place for a pleasant stroll. Off the courthouse square several churches remained, as did the public library and city and county government offices. In the changes of the late twentieth century, the downtown would remain one of Bloomington's best traditions.

The east side of town grew most rapidly after 1945 and contained many of the middle- and upper-middle-class neighborhoods. Green Acres, Arden Place, and then Hoosier Acres provided larger and larger houses by the 1960s, followed in the 1980s by Hyde Park and other subdivisions, marching south and east decade by decade. Growth on the west side, around Highland Village, was slower, but by the 1990s there were new subdivisions and massive retail box stores along the Route 37 Bypass.

New school buildings followed the population into the suburbs. In the baby boom years of the 1950s and 1960s, school officials struggled mightily to provide sufficient classrooms. Consolidation of city and rural county schools (excepting Richland–Bean Blossom) in 1968 caused new challenges. Always, it seemed, there was controversy over redistricting as parents sought to move or to

keep their children in the schools they considered most desirable. And there was still a connection with the past for elementary students who spent a week at Honey Creek, maintained as a one-room school to demonstrate the way it was long ago, before the age of massive multi-room schools and indoor toilets.

Older neighborhoods changed, too. Close to the university, single-family homes became student rentals, sometimes accompanied by late-night noise and morning litter. South of Third Street, Vinegar Hill and Elm Heights contained some of the city's finest older homes, built by prosperous quarry owners, stonecutters, businessmen, and university professors. Elm Heights hung on even after the close of the neighborhood school in 1982. On the near southwest side, Prospect Hill, a neighborhood from the first decades of the century, managed to remain largely unchanged and increasingly attractive, thanks especially to the preservation zeal of the Sturbaum family. On the other side of town, the North Washington Street Historic District was placed on the National Register of Historic Places in 1991, helping to preserve houses built at the turn of the century by the Showers family and other prosperous citizens.

Two neighborhoods showed Bloomington's other side. Pigeon Hill was perhaps the poorest neighborhood in town. Located north of West Eleventh Street, it was settled in the 1920s. A survey in 1954 showed that many of the houses there were built of scrap lumber and tin with dirt floors. Few had central heat or indoor plumbing. Many of the men had once worked in the quarries and at Showers, but such jobs were nearly gone. Strong family networks and the warmth of rapidly growing Pentecostal churches helped lighten the burdens, but "the Hill" was a hard place for many. So was Miller Drive, just south of Hillside Drive. Referred to by some as "little Appalachia," Miller Drive into the 1970s had no city water or sewer service and no streetlights.

Not until the 1960s and 1970s did change come to Pigeon Hill and Miller Drive. Urban renewal efforts brought city services and new housing, including the Crestmont public housing complex along West Eleventh Street, although some residents were forced

to marginal living conditions elsewhere. There was still poverty in Bloomington at the end of the century, and still need for social services such as the Community Kitchen, but the problem was less obvious than it had been a half century earlier.

## NEW BATTLES, NEW LEADERS

*T*he challenges of the last half of the century called forth new controversies and new leadership. As the town became increasingly attractive, even precious, for many residents, more people began to pay attention to the community's general welfare. Bloomington, they said, was becoming too good a place to take for granted. By the end of the century, more than a few citizens would watch cable television broadcasts of city council meetings, sign petitions, and lobby officials.

One of the occasions when many Bloomington citizens thought hard about their community was during the controversy over the old public library. The library was a crown jewel.

There was great pride when a new library building opened on Kirkwood in 1970, and when it was dramatically enlarged in 1997. There were few better examples of the richness of life in Bloomington than the superb public library and the range of events and activities that it housed. Left behind when the new building was constructed was the old building, the Carnegie Library, built in 1918 at Sixth and Washington Streets through the generosity of the steelmaker philanthropist. The city considered selling it to a local business that needed a parking lot. Some were aghast that the beautiful limestone building that had created such warm memories might be demolished. A group of people organized as The Old Library, Inc., and began a petition drive and raised money. In 1977 they purchased the building to convert it into a history museum. The local historical society re-energized itself in this campaign; it moved into the newly refurbished building, and in 1980 opened a museum. With a large wing added in 1998, the Monroe County Historical Society Museum had the beginnings of a first-class mu-

seum and collection. Bloomington was no longer a community embarrassingly short-sighted about its own history.

The fight to save the Carnegie Library was an early battle in historic preservation, a campaign that moved into high gear with the organization of Bloomington Restorations, Inc., in 1975. Headed for a time by Rosemary Miller, an energetic local artist who also headed The Old Library, Inc., BRI conducted historic surveys, saved and restored numerous public buildings and homes, and significantly raised citizen awareness of the losses that bulldozers and wrecking bars caused. BRI reminded residents that even the patterned limestone sidewalks built by WPA workers in the 1930s were worth saving. Bill and Gayle Cook joined preservation efforts through public groups and privately, restoring the Cochran House on North Rogers Street in 1977 and Fountain Square south of the courthouse a decade later.

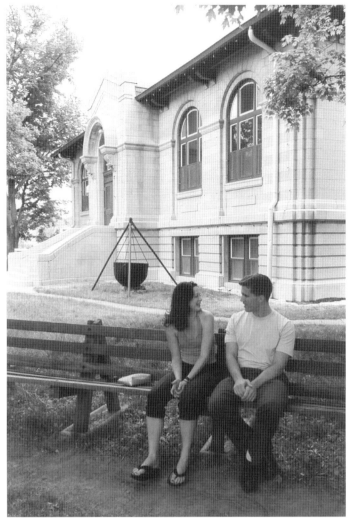

A couple sit on a bench outside the Monroe County Historical Society Museum. The museum, which houses historical exhibits and a genealogical library, is in the old Carnegie Library, which was built in 1918. Spring 2001. WILL COUNTS

Perhaps the largest preservation fight was over the courthouse. Built in 1908, it was badly deteriorated by 1980 and no longer provided enough space for county government. When some proposed that it be torn down, citizens rallied and organized a petition drive. A "Save the Courthouse" campaign was soon in full swing, with the slogan "Can you imagine the Square without it?" Many could not. Renovation rather than destruction was the happy end.

The dedication of the restored courthouse in 1984 was an occasion for civic pride. The fish on the dome, made by early Bloomington blacksmith Austin Seward, became one of the town's primary logos, used in cartoons and on postcards. Its meaning is uncertain, though there have been many opinions. Some liked the guess of one of Seward's descendants, who suggested that the pioneer craftsman chose a fish because it was easier to make than a

rooster or a Miss Liberty. With the fish on the dome and the carved statuary "Light of the World" over the south entrance, the beautiful limestone courthouse stood as one of the town's most important landmarks. Several hundred citizens celebrated New Year's Eve 2000 in the center of their town under the fish and the dome that no longer leaked.

The battles over the courthouse and the public library were not just about the past but about the community and what it valued for the future, about growth and change. Most important, wide citizen involvement in these issues and the emergence of citizen leaders demonstrated new and grander visions of what the community should be.

Many of the new leaders coming forth in the 1970s and 1980s were women. Changing notions of women's roles helped them claim a more visible place. Women had always played a part in the community's public life. In 1905, a group known as the Local Council of Women founded the Bloomington Hospital. Later the League of Women Voters actively studied issues and informed the community about such matters as housing, water and sewage, and elections. In 1962 Mary Alice Dunlap served as mayor of Bloomington, though she was not elected but was appointed to fill a vacancy.

A large number of women emerged to assume wider leadership in the 1970s. One of the most visible was Charlotte Zietlow. Her trademark big hats helped, but more important were her energy and her commitment to the community. She was the first woman elected to the city council, in 1971, and the first elected as a Monroe County commissioner, in 1980. Her challenge to the old boys of local government caused controversy. When they charged that she didn't know anything because she had never met a payroll, she went into business with Marilyn Schultz, a local state representative. Their culinary store, Goods, Inc., located on the square, was soon a successful business. Zietlow played a large role in saving the courthouse, pushing construction of the new Justice Building, and making local government more open and professional.

A 1982 study concluded that women had more political influence in Bloomington than in any other Indiana city. When Tomilea

Allison became the first woman elected mayor in 1983, there were two women on the city council, two representing the area in the state legislature, others in various government positions, and many more leading organizations of all kinds.

One woman who pioneered in race as well as gender was Elizabeth Bridgwaters. Educated in Bloomington's segregated schools, Bridgwaters served on the local school board from 1969 to 1977 and in numerous community organizations. Again and again her presence reminded white Bloomington of matters of race and of justice. In 1999, grateful citizens elected her the county's "Woman of the Century."

## DIFFERENCE AND DIVERSITY

The battles of race were among Bloomington's most difficult. In 1945 blacks were not served in most restaurants or barbershops, not even in the Commons at IU. University president Herman Wells worked, often behind the scenes, to open the campus and community to all. Other citizens began to move also. Ernest Butler, who became minister at the Second Baptist Church in 1959, was soon an outspoken advocate for fair housing and employment. The community began to change. An ad hoc group of 500 homeowners challenged residential segregation when they signed a newspaper ad paid for by the Monroe County Council of Churches in 1961 that asserted, "We welcome into our respective neighborhoods any resident of good character, regardless of race, color, religion, or national origin." There were controversies and tragedies over the years that challenged the city's growing reputation for tolerance: the shooting of Denver Smith by city policemen in 1983; arson at the Jewish synagogue in 1985; the murder of Korean student Won-Joon Yoon in 1999 by a racist fanatic.

In 1972, Mayor Frank McCloskey led the way in passing the city's human rights ordinance. Three years later, amid much controversy, the city council voted unanimously to give the new human rights commission power to decide cases of discrimination

involving sexual orientation. Incidents of "gay bashing" did not end, but by the 1980s Bloomington had a reputation as a place where it was easier to be different.

Movement toward greater tolerance did not solve problems of difference. The challenge of the Ku Klux Klan in the late 1960s heightened the issue. Representing a small group of ignorant whites, the Klan announced a visit to Bloomington in 1968, causing an injunction and later arrests of several Klan members for illegal possession of dynamite. Though the Klan denied responsibility, the firebombing of the Black Market in December 1968 seemed to bring the worst of hatred to Bloomington. This small shop on Kirkwood sold African and African American items, a symbol too enticing for two young males, one an escapee from the state mental institution. Violence on Kirkwood left bad memories. And it left a vacant lot that young people took over as a homemade park. A decade later, a local citizen purchased the land and donated it for a city park, soon known as Peoples Park.

There is little doubt that Bloomington became more tolerant of difference in the last decades of the century. The changes of the 1960s had special effect because of the influence of the university. Youthful protests and demonstrations often spilled into the larger community and sometimes caused anger on all sides. The town-gown split that faced all college towns was surely evident in Bloomington in these years, a version of which was portrayed in the Oscar-winning Hollywood film *Breaking Away*. But in the last couple decades of the century, such tensions seemed to melt. More and more long-term residents were connected to the university. IU seemed less alien or threatening.

Over the years, Bloomington became more liberal and more diverse. Indeed, by the end of the century it was this diversity that more than anything else marked the city as different from other towns of southern Indiana and the Midwest. Some viewed it as an oasis surrounded by desert; others as a Sodom and Gomorrah set in a heartland of righteousness; still others as a little of both. Many saw it as just a nice place to live because there was so much happening.

## FOOD AND FUN

*O*ne of the most obvious changes was culinary. As late as 1965, Bloomington was a meat-and-potatoes town. The few fancy restaurants featured steak and baked potatoes; others offered chicken and dumplings or meat loaf and string beans, good basic American food. There was a Chinese restaurant or two, but little else. Pizza came first as exotic food when the Pizzaria opened on Kirkwood in 1953. But newcomers from across the nation and world brought far more.

Some would say that a major turning point in Bloomington came in 1971 with the opening of the Tao restaurant on East Tenth Street, just a few doors from the fur shop of Medal of Honor winner Gerry Kisters. The Tao served vegetarian food, freshly prepared: spinach lasagna, homemade yogurt, sourdough bread, French baguettes, poppy seed cake, and cappuccino. As exotic as the food was the fact that the restaurant was part of the growing business operation of the Rudrananda Ashram, a group that studied Indian philosophy and lived communally. Some residents saw the Tao as part of a hippie cult and continued to prefer meat and potatoes, but until it was sold in 1982, the Tao was among the most interesting places in town.

The Tao was the first in a long line of distinctive restaurants, places serving all kinds of ethnic foods. East Fourth Street became an enclave, but other restaurants sprang up throughout the town. People began to come to Bloomington to eat, and eventually the local paper began a modest weekly food column.

Shopping and entertainment diversified, too. Possibilities ranged from local acting companies, to craft fairs, particularly the Fourth Street Festival of the Arts and Crafts, begun in 1977,

Michael Shoemaker sits in the Rudrananda Ashram in Bloomington. Shoemaker founded the communal living and spiritual center, which ran the Tao, Bloomington's first vegetarian restaurant. August 1972.   DAVE REPP

to film series, especially the independent Ryder series. There were art galleries and shops that sold unusual items, imported, hand-made, quirky. The opening of the Waldron Arts Center in 1992 in the old city hall and police station, followed by the renovation of the Indiana Theater, brought a focal point to the arts. And music blossomed—all kinds of music, and many places to play and listen. The university provided much of the music, but sounds spread off the campus. The town claimed not only Hoagy Carmichael, John Mellencamp, and Joshua Bell, but many others who found fellow musicians and audiences. The beginning of the Lotus World Music and Arts Festival in 1994 added even more musical zest.

There were unusual things to see and do in Bloomington. A Tibetan cultural center appeared in a cornfield east of town, and a Buddhist monastery near Cascades Park. And of course there was the university, with its more than 35,000 students, which continued to attract people of talent and intellect who brought dashes of spice to the town from all over the world. Bloomington became a hip place, a town of youthfulness and energy. In the 1990s it began to appear on lists of the best college towns in the nation.

Bloomington also became a regional center, attracting visitors from south-central Indiana and beyond. Many came often to shop, for an IU basketball game, a good meal, an art show, a concert. Some came for health care at Bloomington Hospital. Students who had been here for only four years found that they didn't want to leave. Alumni returned. Older Americans looking for a good place to retire found Bloomington on many recommended lists. The opening of Meadowood as a planned retirement community in 1983 spurred such choices.

## TWENTY-FIRST-CENTURY CHALLENGES

*G*rowth brought continuing challenge and sometimes divided the community. How many apartments should be built close to a neighborhood of single-family homes? How many yellow bulldozers did citizens need tearing up the land? Did the town need a

new interstate highway? More golf courses? More signs and billboards? More parking lots? Were there sufficient natural resources—land, air, and water—to sustain the growing population? Would growth create sprawl and traffic congestion that would choke the town? Would too much growth spoil Bloomington? And how much diversity was necessary, how much tolerance for those who were "different"? How much compassion for those still restricted by economic or cultural boundaries?

These were not the kinds of questions most citizens had struggled with much in the first half of the twentieth century, with the major exception of the inadequate water supply. Bloomington then was more like other Midwestern towns, more content with its ordinary qualities. Only in the last half of the century had it become something different. Quietly, mostly to themselves, many residents would say that Bloomington had also become something better, much better.

There were Bloomington residents at the beginning of the twenty-first century who had heard the Metropolitan Opera perform *Aida* in the University Auditorium in 1942; given their sex histories to Alfred Kinsey in the 1940s; subjected their teeth to the stannous fluoride tests that produced Crest toothpaste in the early 1950s; listened to Gene McCarthy and Bobby Kennedy explain why the Vietnam War was wrong in 1968; heard not only Elvis but also Bill Monroe, the Supremes, and Ray Charles; participated eagerly in a new curbside recycling program begun in the early 1990s; bought sushi and tofu at the grocery store; and listened to the Dalai Lama more than once. The small town in southern Indiana was hardly isolated or ordinary.

Just as important to many was the small-town style that made honking a car horn distasteful; that allowed for conversation with a friend or stranger while selecting tomatoes at the grocery store, or, even better, at the Saturday farmers' market; that encouraged postponing reading the world news at breakfast to scan first the obituaries, the police beat, and the letters to the editor. In such happy combinations of old and new were to be found the origins of the very special place that Bloomington had become.

Unfortunately there is no up-to-date, detailed history of Bloomington or Monroe County. The vertical files in the Indiana Room of the Monroe County Public Library are most helpful for more recent events. The following readings provide some further steps toward understanding the community's past.

Joseph A. Batchelor, *An Economic History of the Indiana Oolitic Limestone Industry* (Bloomington: The School of Business, Indiana University, 1944).

Bloomington Department of Redevelopment, *City of Bloomington: Interim Report* (Bloomington: Department of Redevelopment, 1986).

Robert Carleton, Esq. [Baynard Rush Hall], *The New Purchase; or, Seven and a Half Years in the Far West* (New York: D. Appleton & Co., 1843, 1916).

Thomas D. Clark, *Indiana University: Midwestern Pioneer,* 3 vols. (Bloomington: Indiana University Press, 1970–1977).

Jefferson Cowie, *Capital Moves: RCA's Seventy-Year Quest for Cheap Labor* (Ithaca, N.Y.: Cornell University Press, 1999).

Karen S. Craig and Diana M. Hawes, *Bloomington Discovered* (Bloomington: Discovery Press, 1980).

Emily Styron Duncan and Karen L. Perry, *Bloomington Environmental Quality Indicators* (Bloomington: Environmental Commission, City of Bloomington, 1994).

Frances V. Halsell Gilliam, *A Time to Speak: A Brief History of the Afro-Americans of Bloomington, Indiana, 1865–1965* (Bloomington: Pinus Strobus Press, 1985).

Philip Todd Holland, "I Remember It This Way," *Indiana Magazine of History* LXIX (September 1973), 193–273.

Hortense Holloway, "The Social Study of the Negro Community in Bloomington" (M.A. thesis, Indiana University, 1946).

Larry Lockridge, *Shade of the Raintree: The Life and Death of Ross Lockridge, Jr.* (New York: Penguin, 1994).

James H. Madison, *The Indiana Way: A State History* (Bloomington: Indiana University Press, 1986).

William H. McDonald, *A Short History of Indiana Limestone* (Bedford, Ind.: Lawrence County Tourism Commission, 1995).

Louis H. Orzack, "Employment and Social Structure: A Study of Social Change in Indiana" (Ph.D. dissertation, Indiana University, 1953).

Maie Clements Perley, *Without My Gloves* (Philadelphia: Dorrance and Company, 1940).

Scott R. Sanders and Jeffrey A. Wolin, *Stone Country* (Bloomington: Indiana University Press, 1985).

George Vlahakis, *A Contemporary Portrait: Bloomington* (Montgomery, Ala.: Community Communications, 1998).

*Will Counts*

# Photographic Essay

Schoolchildren pose for photographer
Clyde "Red" Hare. This photograph is
from the files of the IU Art Museum.
Circa 1950.   CLYDE HARE

Corn growing beside Memorial Hall.
MONROE COUNTY HISTORICAL
SOCIETY MUSEUM

A horse and buggy stand in front of the IU Library. After the new library was completed on Tenth Street, this became the Student Services Building in 1972. It was renamed Franklin Hall in 1988. 1907. (From the scrapbook of Floy Underwood.)   IU ARCHIVE

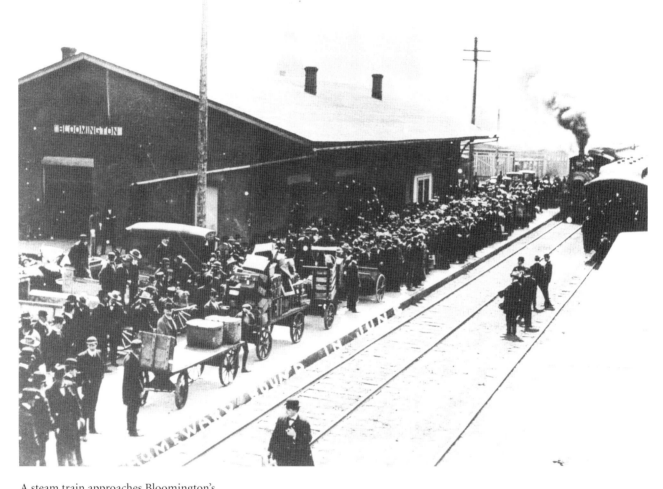

A steam train approaches Bloomington's
station on the Monon line as IU students
line up to return home after the end of
classes in June. Train travel was a
popular way to get to and from the
university.   IU ARCHIVE

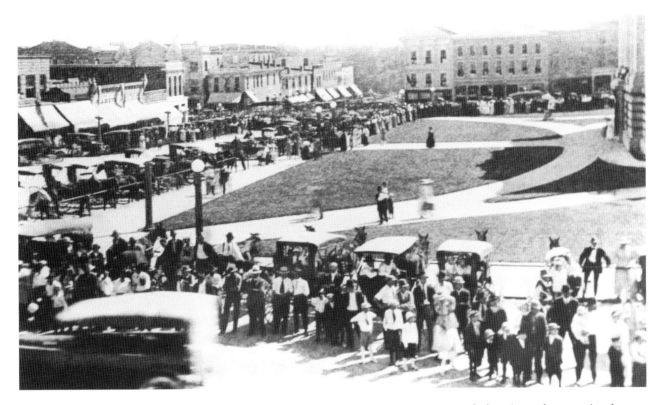

People, buggies, and an occasional automobile surround the eastern portion of the courthouse square. The crowd was probably waiting for a parade. 1918.   IU ARCHIVE

Kids play basketball in a converted barn loft. For generations, Indiana has been known for its love of basketball, and for producing good players.
HARTLEY ALLEY

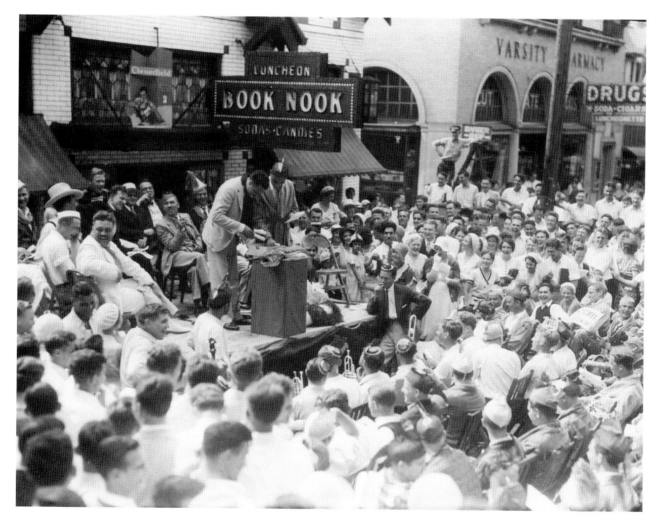

Herman B Wells (*on stage in white suit*) waits to receive his "Doctor of Nookology" degree at the 1931 Book Nook commencement on Indiana Avenue. This was the last of these "for fun" gatherings. 1931.   IU ARCHIVE

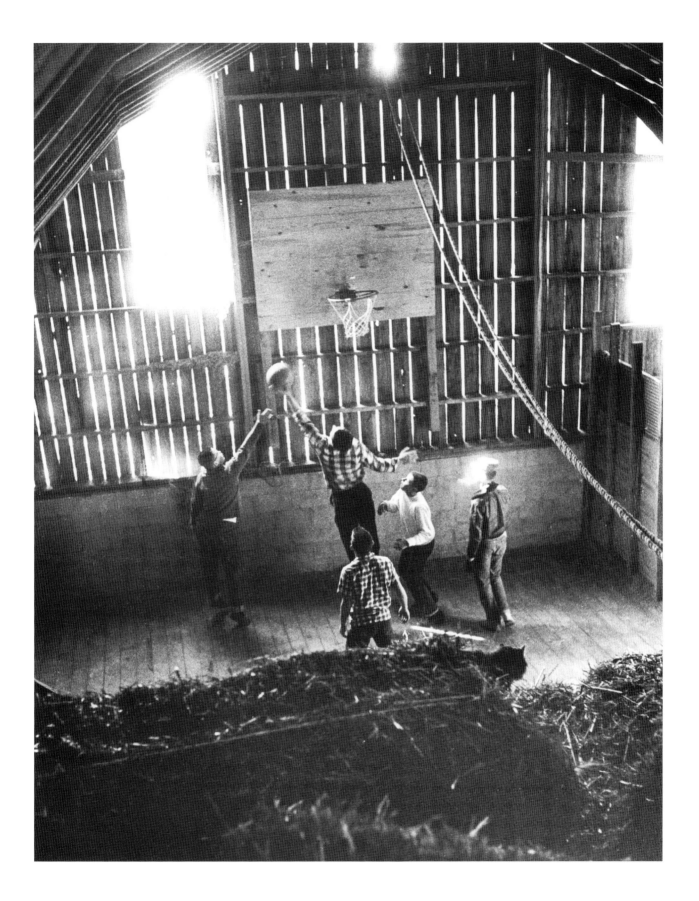

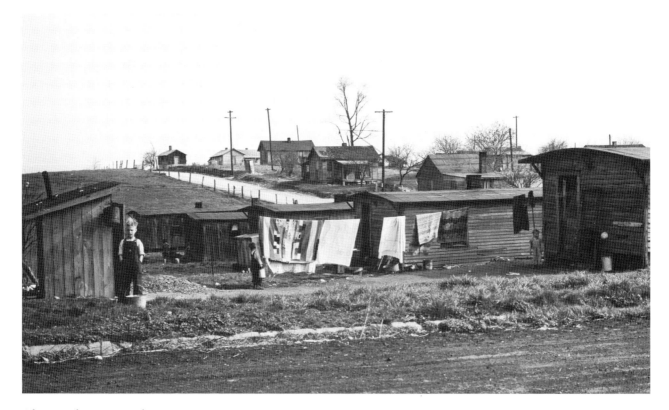

A boy stands near an outhouse on
Pigeon Hill. Settled in the 1920s, "the
Hill" was long one of Bloomington's
poorest neighborhoods. Urban renewal
efforts in the 1960s and 1970s brought
city services and new public housing
to the area. 1941.

HENRY HOLMES SMITH

Children cultivate their vegetable plots at the Hilltop Garden on the IU campus. Since it was founded in 1948, thousands of youth have participated in the gardening program. July 10, 2000. WILL COUNTS

Previous overleaf: The tops of the IU Student Building (*center*) and the Monroe County Courthouse (*rear*) rise above the trees of Bloomington. September 1983.   DAVE REPP

Kathleen C. Freeman, 91, sits on her West Fourth Street front porch. For forty-three years Mrs. Freeman worked for Indiana University. Many of the homes on her block have been converted into multiple apartments, but her home has remained a single-family dwelling. August 14, 2000.   WILL COUNTS

A Ferris wheel towers over the Fun Frolic, an amusement park set up in the Memorial Stadium parking lot. A Bloomington tradition for more than forty years, the Fun Frolic generates funds for child care programs. June 19, 2000. WILL COUNTS

Scott Burton and his stepson Michael Ingram, 5, sit on top of their truck watching racing at the Bloomington Speedway south of town on Old State Road 37. Motor racing fans have been coming to this track since 1923. August 11, 2000. WILL COUNTS

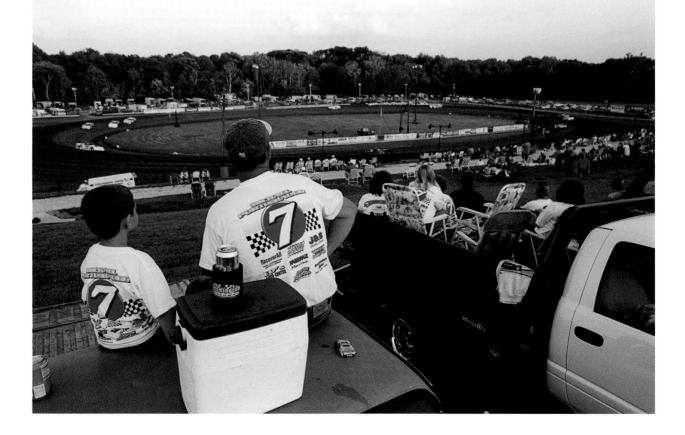

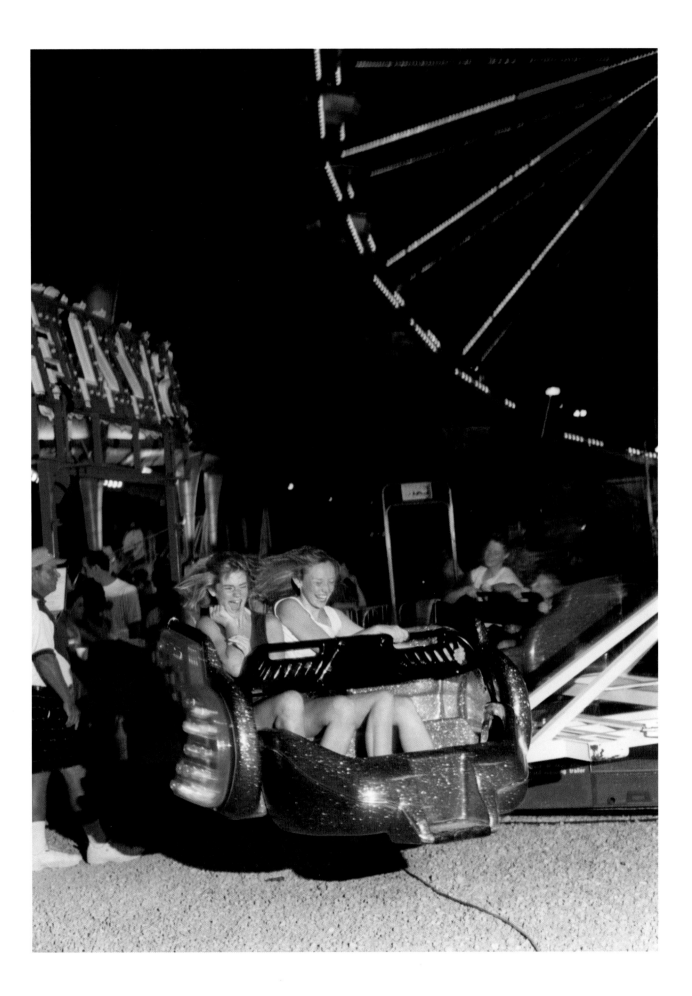

The Monroe County Courthouse looms
above the Smith-Holden Music
Company. The musical score on the side
of the Smith-Holden building is "Three
Epitaphs" by Dr. Thomas Beversdorf.
November 2000.   WILL COUNTS

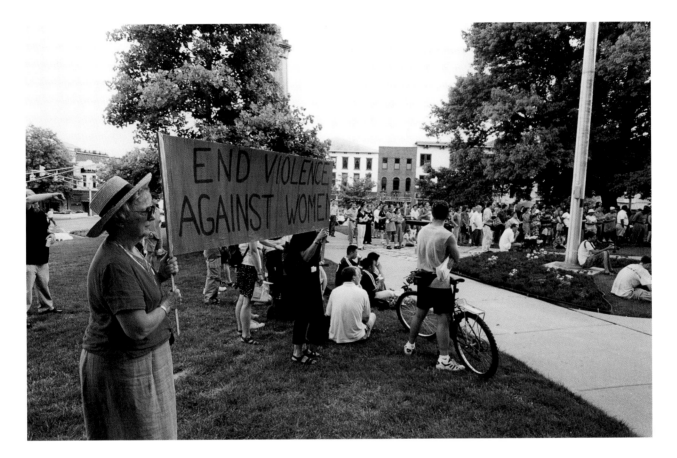

Charlotte Zietlow (*foreground*) holds a
protest sign outside the Bloomington
County Courthouse during an anti-hate
protest march from the IU campus to
downtown Bloomington. It was held
on the anniversary of the day that
Won-Joon Yoon, an IU student from
Korea, was killed in a hate crime.
July 6, 2000.   WILL COUNTS

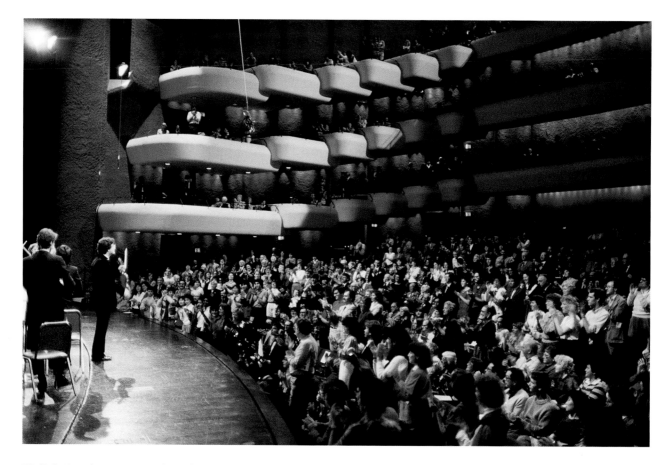

Violinist Yuval Yaron responds to the
audience at the IU Musical Arts Center
as they honor music professor Josef
Gingold on his birthday. The MAC,
dedicated in 1972, is a venue for School
of Music productions of opera,
symphonies, and band concerts.
October 1984. WILL COUNTS

Bicyclists travel along North Old State Road 37 near Bloomington during the Hilly Hundred bike tour. The annual event attracts thousands of cyclists who pedal through scenic southern Indiana, often at the peak of its beautiful fall foliage season. October 2000.

WILL COUNTS

Riders in the Little 500 bike race are a blur as they speed around the track. The annual race began in 1951 at the Tenth Street Stadium, moving to Bill Armstrong Stadium when it was built in 1981. 1980s.   SCOTT GOLDSMITH

Indiana University's Main Library is reflected in a lake where the old football stadium once stood. Construction of the building began in 1966, using concrete panels faced with blocks of Indiana limestone. 1990.   WILL COUNTS

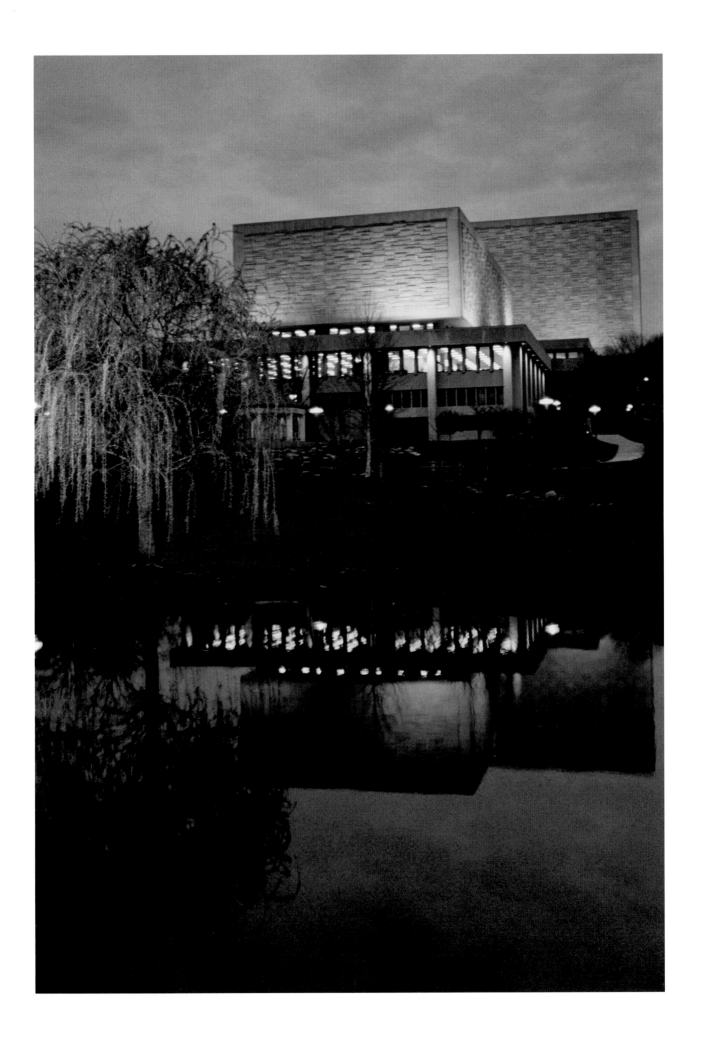

Jack Moore and his wife, Gretchen, help
their granddaughter, Melissa, move into
her room at Foster Quad. At left is
Melissa's mother, Jennifer. August 1999.
WILL COUNTS

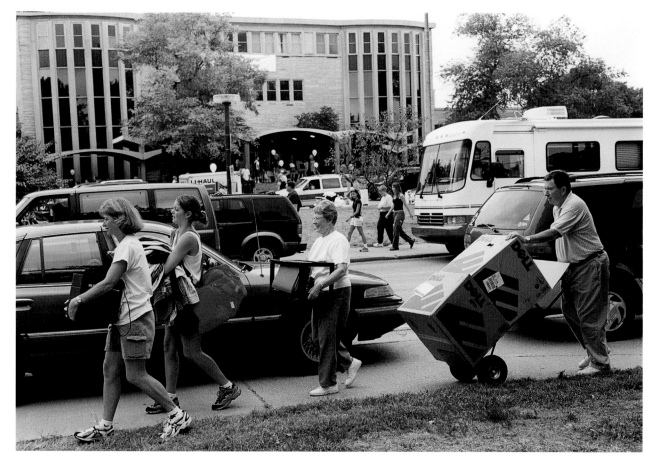

A bicyclist crosses the street in front of Showalter Fountain late in the afternoon on a spring day. The fountain, by sculptor Robert Laurent, was installed in the fall of 1961. Circa 1980.
SCOTT GOLDSMITH

Patrons pass through the outer lobby of
the IU Auditorium. The lobby is noted
for its recently restored Thomas Hart
Benton murals, *The Social History of
Indiana.* The murals were created for the
Indiana display at the Chicago World's
Fair of 1933. After they returned to
Indiana, IU president Herman B Wells
discovered that they had been placed in
storage at the state fairgrounds. He
quickly got permission to bring them
to Bloomington. December 2000.
WILL COUNTS

The presentation of colors kicks off a July 4th concert by the Bloomington Pops at IU's Bill Armstrong Stadium. July 4, 2000.   WILL COUNTS

A lone man walks past the Indiana Arc
outside the Indiana University Art
Museum. Artist Charles Perry designed
this painted aluminum sculpture
specifically for this site near the museum
designed by I. M. Pei. 1996.
WILL COUNTS

The faculty proceed to their positions at an IU graduation ceremony in Memorial Stadium. The football stadium is the only venue on campus large enough to accommodate all IU Bloomington graduates. May 2000.   WILL COUNTS

Girls play at Mills Pool in northwest
Bloomington. The pool is one of two in
town run by the Bloomington Parks and
Recreation Department. August 2000.
WILL COUNTS

An IU music student practices his tuba
outside on a spring day, near a stream
that runs through campus. Circa 1980.
SCOTT GOLDSMITH

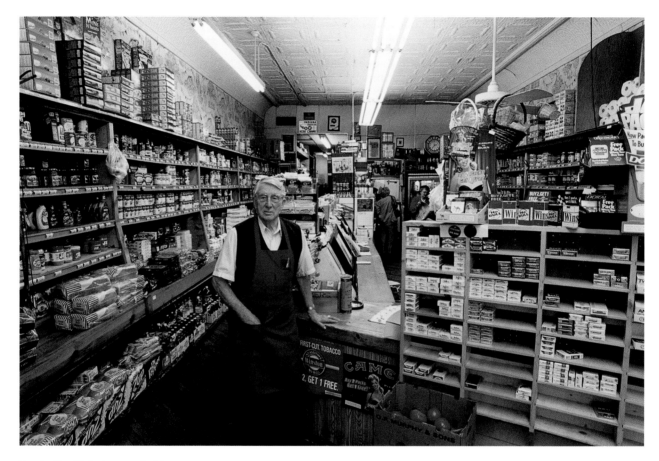

Charles "Bud" Faris poses in his
downtown Bloomington food market.
The store has been in the family since
1923. The market does much business
delivering custom orders to IU
fraternities and sororities. 2000.
WILL COUNTS

The Dalai Lama, the spiritual leader of Tibet, bows as he leaves the stage at the Tibetan Cultural Center on Snoddy Road. His brother, Thubten Jigme Norbu, an IU professor, founded the center, and the Dalai Lama has visited several times. 1987. WILL COUNTS

A student walks through Dunn's Woods on the IU campus. The natural beauty of the campus has long drawn students to IU. The woods have been designated a protected green area by the university. Fall 2000. WILL COUNTS

The sun shines through the trees near Hoagy Carmichael's gravesite in Rose Hill Cemetery. Carmichael, who was born and raised in Bloomington, is perhaps best known for composing the classic song "Stardust." July 24, 2000.   WILL COUNTS

Overleaf: Fireworks light up the sky above IU's Bill Armstrong Stadium, viewed by people attending the annual "Picnic with the Pops." July 4, 2000. WILL COUNTS

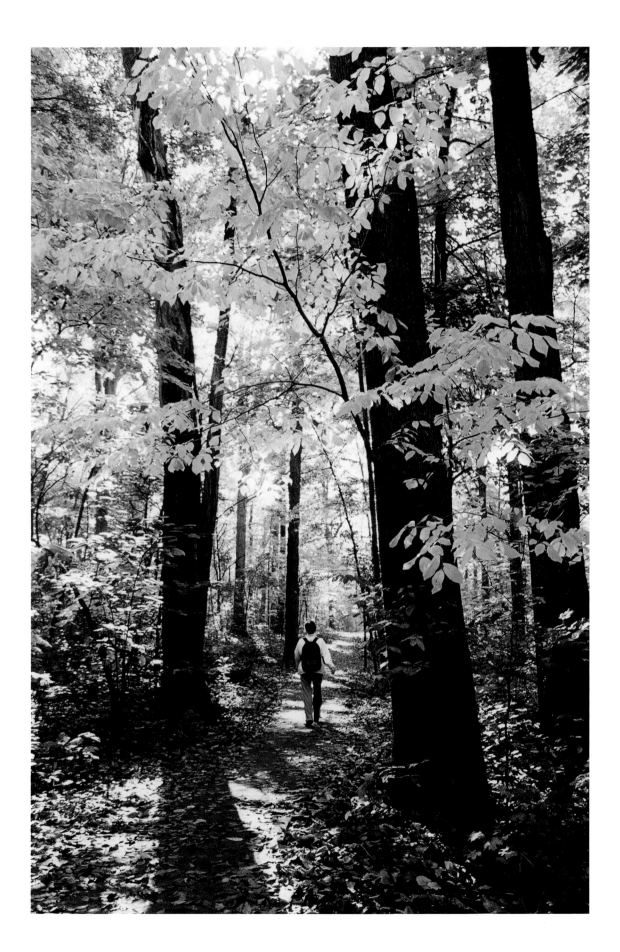

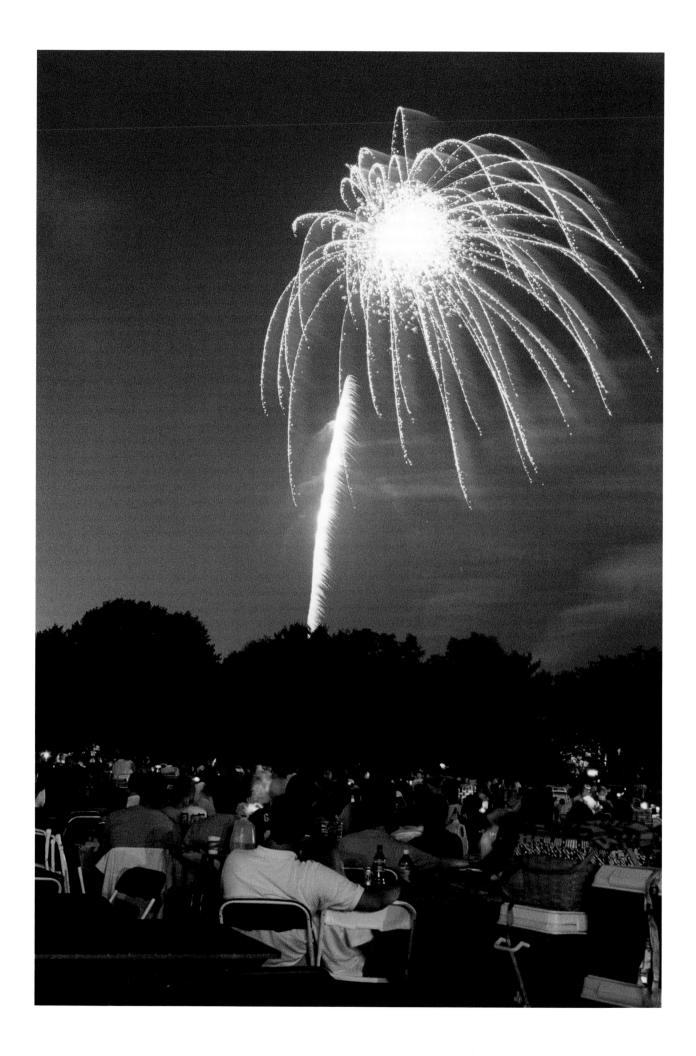

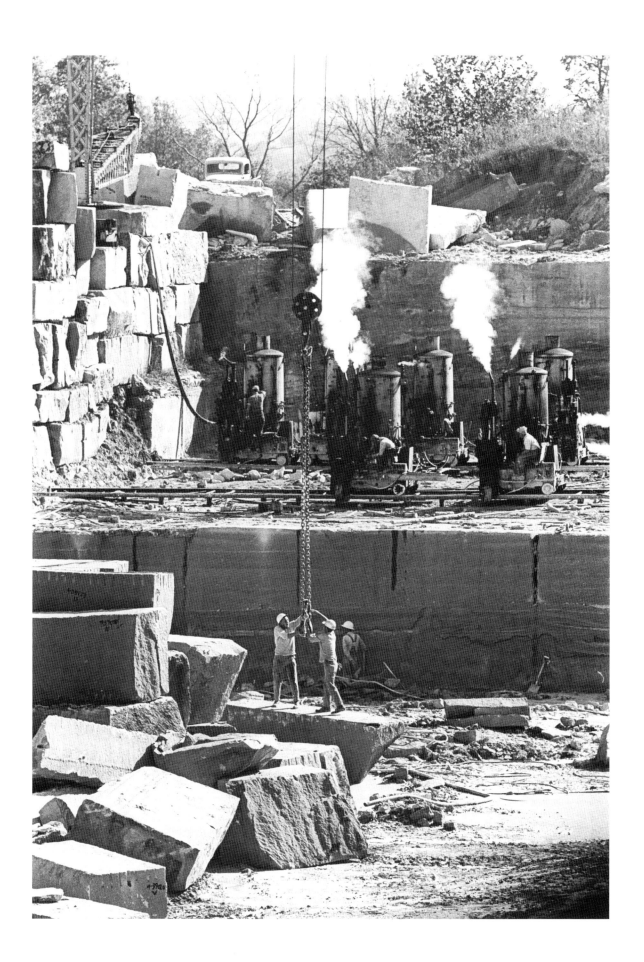

Previous overleaf: Limestone quarries, which surround Bloomington on three sides, have been a visible part of the city's landscape since the late nineteenth century. In this image, steam-driven limestone cutting tools called channelers are being used. Circa 1940s.
HARTLEY ALLEY

This photograph by Jack Welpott is part of the collection at the IU Art Museum. Welpott, a native of Bloomington, took this candid picture while studying photography at IU. 1950.
JACK WELPOTT

Men lounge outside the First National Bank in downtown Bloomington. A bank has been located on this site at Kirkwood and Washington for many years. Circa 1950s.  RALPH VEAL

A crowd gathers for a July 4th parade,
with a billboard promoting the Bible in
the background. Circa 1950s.

RALPH VEAL

Cars turn east on Kirkwood at the courthouse square during a celebration of IU's NCAA basketball championship in 1953. The team beat Kansas for the title. Fans met the players at the airport and had this impromptu parade around town. 1953.   IU ARCHIVE

IU photographer Paul Rouse poses beside his Polaroid camera at the IU Fun Frolic. As a member of the staff council, which then sponsored the annual carnival to raise funds for scholarships, Rouse set up this booth to take photographs of people posing behind funny cutouts. Circa 1960s.
BARNEY COWHERD

IU football fans cheer during the homecoming game against the University of Iowa. 1965.
BARNEY COWHERD

A woman browses through a book rack at the Black Market on Kirkwood. The market, which sold Black Power books, African jewelry, and other items, was firebombed in 1968. The site later became Peoples Park. 1960s.

BARNEY COWHERD

A group of young people relax in the bed of a truck as they head for the Bean Blossom Bluegrass Festival. Early 1970s.
KAREN ELSHOUT

When Secretary of State Dean Rusk came to IU to speak in support of the administration's policy to send troops to Vietnam in 1967, he was greeted by signs both supporting and opposing U.S. involvement in Vietnam. 1967.

BARNEY COWHERD

Gary Atwood turns around to look at Angela DeAngelis on campus in late 1969. The couple later married, and Angela became a member of the Symbionese Liberation Army. She died in a confrontation with police in 1974.

JERRY MITCHELL

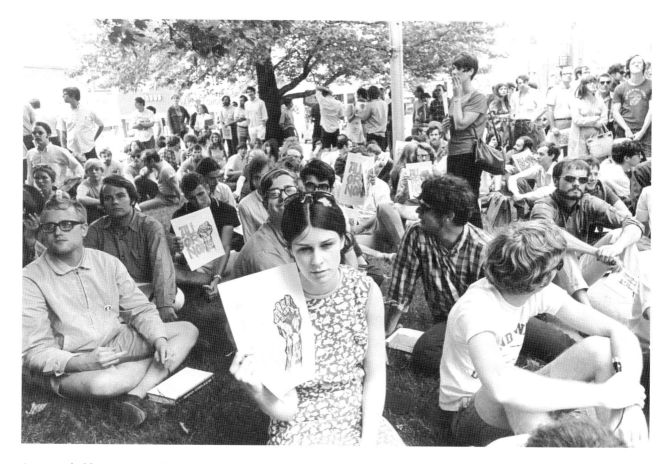

A woman holds up a poster of a
clenched fist during a Black Power rally
at the Monroe County Courthouse.
Circa 1968.　BARNEY COWHERD

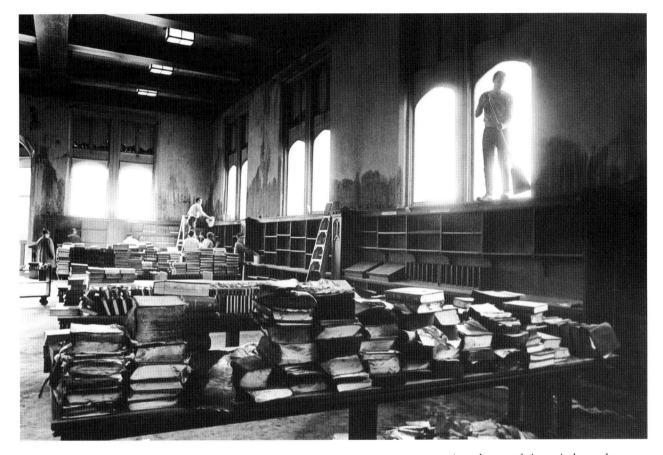

A worker stands in a window as he sweeps up after a fire in the IU Library, now Franklin Hall. The 1969 fire resulted in $600,000 worth of damage and was believed to be the work of an arsonist. May 1969.

BARNEY COWHERD

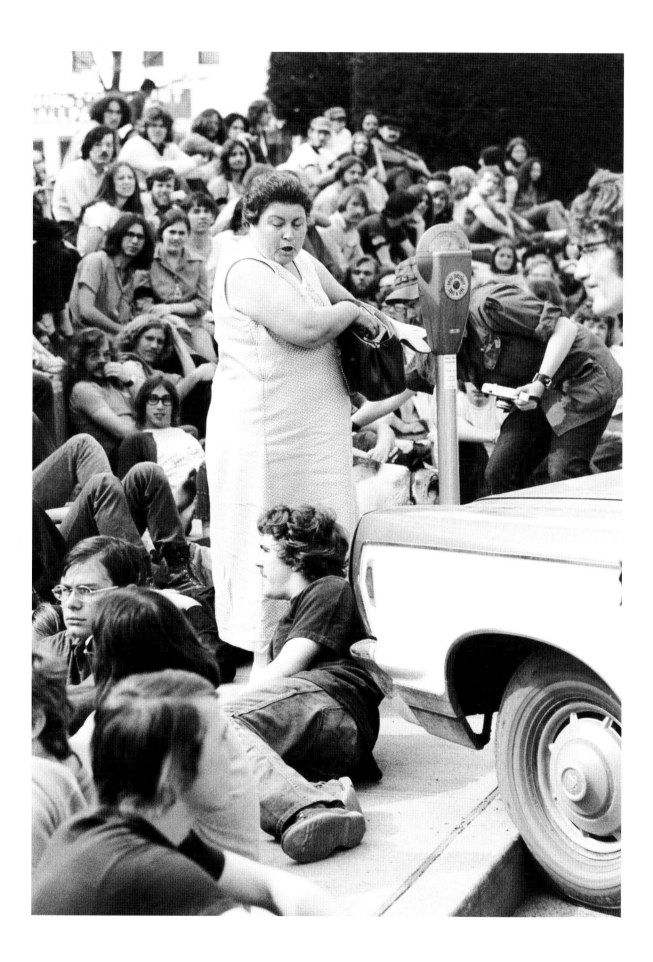

A woman reaches into her purse to feed
a parking meter near the Monroe
County Courthouse, while around her
an anti-war "sit-in" is taking place.
April 1972.   DAVE REPP

A young woman is embraced by a
man in a Ford Mustang outside the
Bloomington Academy of Beauty
Culture on College Avenue.
October 1971.   DAVE REPP

A woman does a swan dive into a quarry southwest of Bloomington. For years, the quarries were popular swimming spots. May 1975.   DAVE REPP

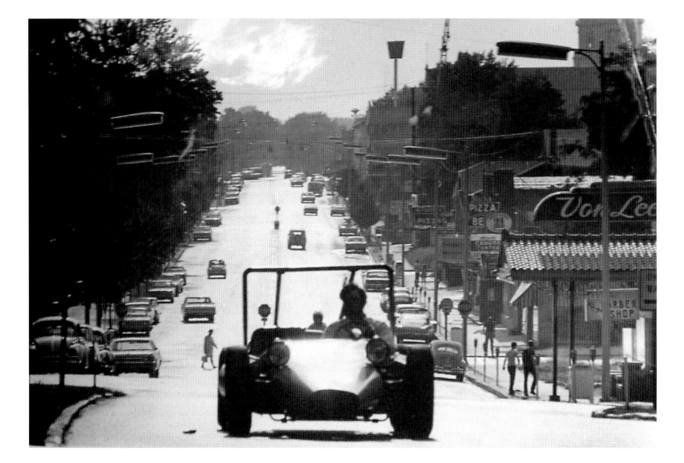

Silhouetted by the sun, a dune buggy heads east on Kirkwood toward the IU campus. Kirkwood continues to be the main artery between the campus and downtown Bloomington. Early 1970s.
IU ARCHIVE

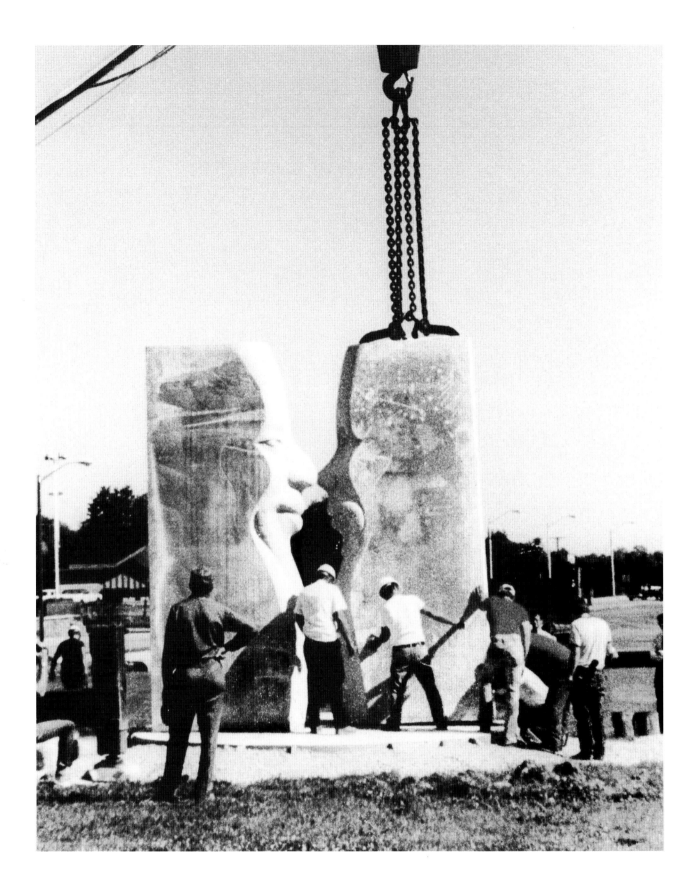

*Red, Blond, Black, and Olive,* consisting
of two ten-ton slabs of limestone, is
placed in position in Miller Showers
Park in 1980. Sculptor Jean-Paul
Darriau's design represents the cultural
diversity of Bloomington. The faces are
Asiatic, Nordic, African, and Indian.
1980.  MONROE COUNTY HISTORICAL
SOCIETY MUSEUM

Stefan Cluver and Jennifer Mickel have a
close conversation while a band plays
nearby in the South Lounge of the
Indiana Memorial Union. The lounge
has long been a favorite place for
students to study and gather.
Circa 1980.  BILL WARREN

Two stuffed mountain goats are among
the items displayed at an auction at
Jimmy Schmalz's farm. His family ran
Schmalz's store in downtown
Bloomington, which was known for
the mounted animals on its walls.
1991.   RICH REMSBERG

A girl holds her chicken during judging at the 4-H poultry competition at the Monroe County Fair. 1999.

RICH REMSBERG

Spectators line up along a fence as they
watch a demolition derby at the Monroe
County Fairgrounds. 1996.
RICH REMSBERG

A Sixth Street house and its
surroundings are viewed at night from
the IU parking garage to the north.
Circa 1990. ROGER PFINGSTON

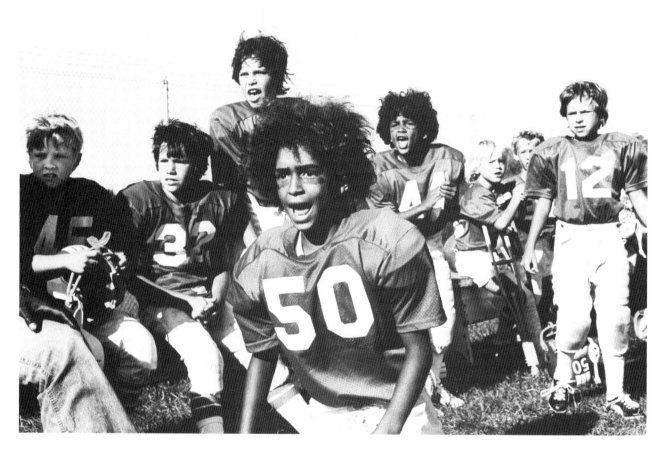

Boys on the sidelines of a Bloomington
Junior League football game cheer for
their teammates. 1978.
ROGER PFINGSTON

A small girl reacts enthusiastically to the "big girls" marching in the 4th of July parade on Walnut Street in downtown Bloomington. July 4, 1999.

ROGER PFINGSTON

Local musicians entertain passers-by on Kirkwood Avenue during the Lotus World Music and Arts Festival, an annual celebration of performances by musicians and singers from around the world. 1999.  ROGER PFINGSTON

Patrons enter the Buskirk-Chumley Theatre. Formerly the Indiana Theater, the now-restored Buskirk-Chumley is a venue for performing arts. April 2000.
ROGER PFINGSTON

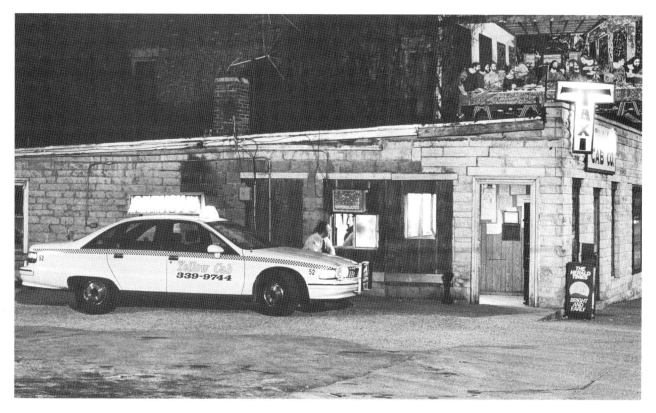

A taxi cab and driver wait outside the Yellow Cab office on West Sixth Street. Circa 1990.  ROGER PFINGSTON

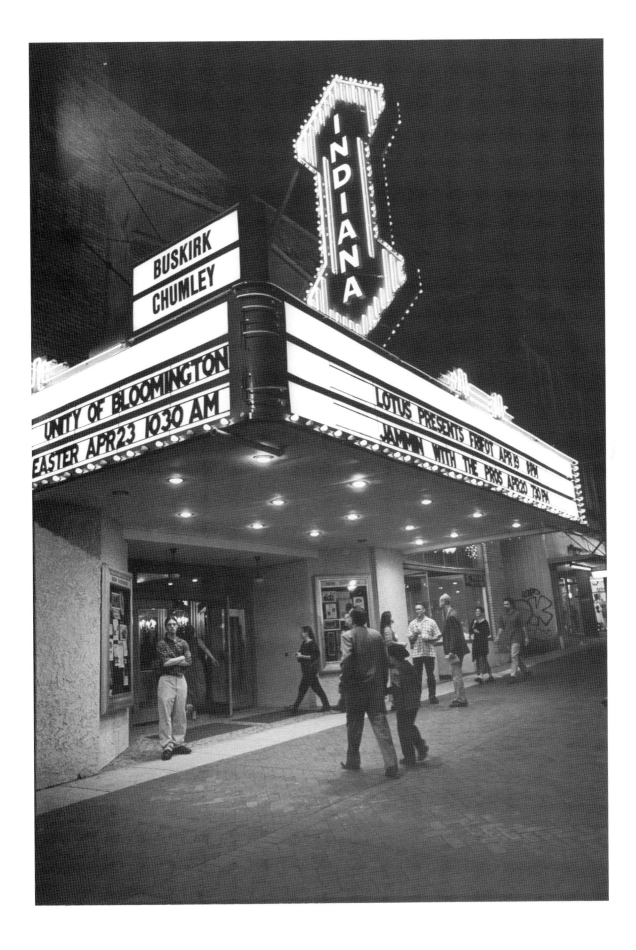

Laura Green (*left*) teaches a class at the
John Waldron Arts Center. The
community center has an auditorium for
plays and concerts, a gallery for art
exhibits, and space for art classes such as
this one. April 2001.   WYATT COUNTS

Teenager Jake Cru, wearing chains and spiked bracelets, crosses Fourth Street. Bloomington is home to a lively mix of ages and cultures. April 2001.
WYATT COUNTS

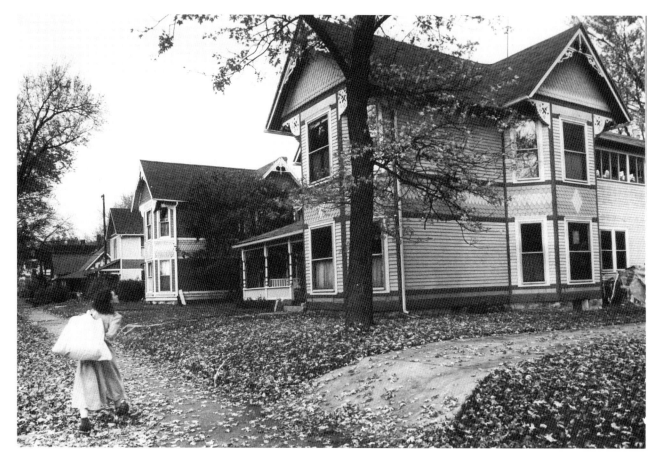

A woman walks up North Washington
Street on a fall day. The neighborhood,
one of Bloomington's oldest, contains
many historic homes, some of which are
being restored. 1989.   WILL COUNTS

Wylie House, the home of IU's first president, Andrew Wylie, is nearly hidden from view on Second Street. The house is now a museum, with some of Wylie's original furnishings from the nineteenth century. 1989.
WILL COUNTS

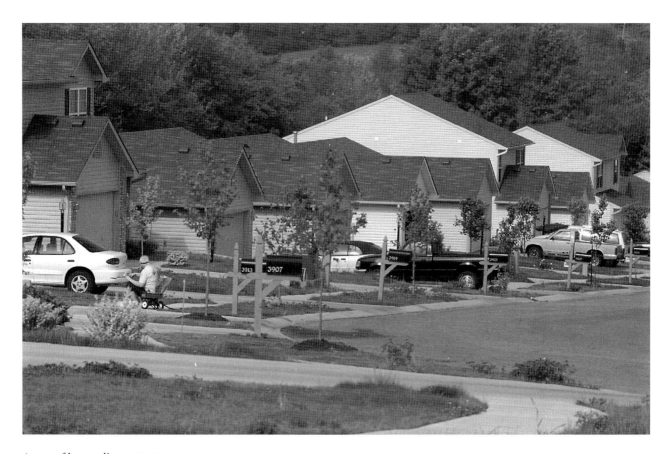

A row of houses line a street on Bloomington's west side, where not long ago there were empty fields. This part of Bloomington is booming, with the rapid development of big box stores and restaurants along the Highway 37 Bypass. 2001.  WILL COUNTS

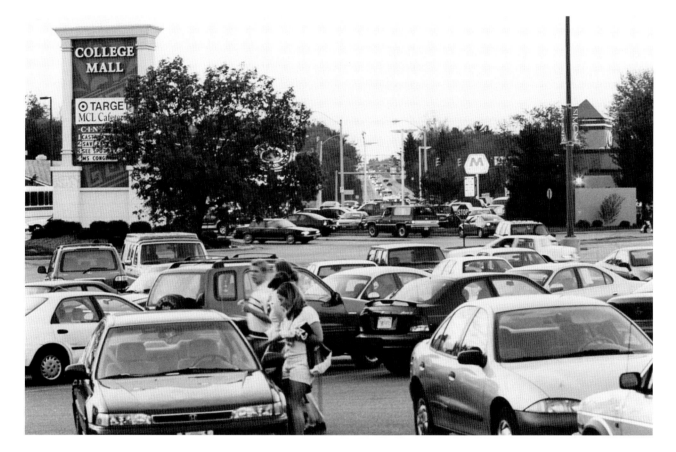

A couple get into their car outside the College Mall on Bloomington's southeast side. Traffic has become increasingly heavy in this area of town. A plan has been implemented for retail growth on the west side, which was intended to take pressure off this area. May 2001.
WILL COUNTS

St. Charles elementary students play basketball during a recess at the parochial school on Bloomington's east side. While most Bloomington students attend public school, there are several parochial and private schools in town. Spring 2001.   WILL COUNTS

YMCA

Members of an exercise class stretch at the YMCA's track. The YMCA provides fitness classes and recreational facilities for all ages. 1988.   WILL COUNTS

Eva Sanders leads her exercise class at
the Bloomington Adult Community
Center. Many older Americans have been
drawn to Bloomington, which has been
touted in several national publications as
a great place to retire. Ms. Sanders has
led this class for two decades.
2000.   WILL COUNTS

Harry Magner cuts hair in Charlie's barbershop on West Fourth Street. Charlie Franklin has owned and operated the two-chair shop since 1963. The shop has no telephone. Charlie says he tried having a phone, but "it just kept ringing, breaking up my work, and the caller would want to know if I would be busy in an hour and I didn't know if I would be busy." So the phone was removed. 2001. WYATT COUNTS

A crowd gathers in front of the Lilly Library for a summer band concert. In the foreground is the Venus sculpture in Showalter Fountain. 1994.
WILL COUNTS

This display at the Monroe County Historical Society Museum contains artifacts such as a photograph of composer Hoagy Carmichael and a statue of "Nipper," the dog that served as a symbol of RCA during the years when one of its major plants was in Bloomington. There are also items related to Bloomington's basketball tradition. Spring 2001.　WILL COUNTS

Overleaf: There are several golf courses in and around Bloomington, but the municipal course in Cascades Park north of town remains a favorite. It is located on rolling hills among beautiful mature trees. The course has low greens fees and twenty-seven holes open for play. Spring 2001.　WILL COUNTS

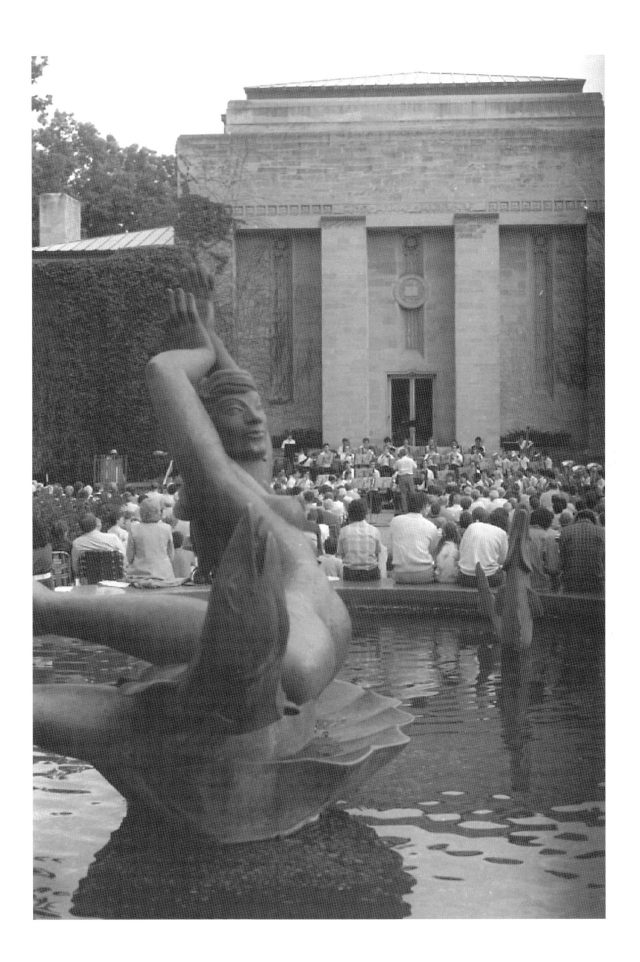

# WILL COUNTS, 1931–2001

Will Counts was a pioneer in his ceaseless advocacy for the visual literacy of all journalism students and practitioners. In classrooms and newsrooms, Will argued passionately for the values to readers of the information, emotion, and insight that images convey. He argued passionately for equality of status in news-editorial decision making for photojournalists and picture editors.

In teaching his students to be not only skilled, empathetic photojournalists but also leaders in newsrooms, Will profoundly affected their dreams and ambitions. Because he was for them as his students and then throughout their careers, Will won the hearts and minds of generations of photojournalists. They admired him as a marvelous photojournalist, respected him as an inspiring teacher, and loved him as a friend and mentor.

TREVOR BROWN
DEAN, SCHOOL OF JOURNALISM
INDIANA UNIVERSITY

**Will Counts** was an Arkansas native who lived in Bloomington, Indiana, from 1960 until his death in 2001. For thirty-two of those years, he taught photojournalism at the IU School of Journalism. Before he began teaching, he worked as a photographer-editor for the *Arkansas Democrat* in Little Rock and for The Associated Press in Chicago. Will's wife, Vivian, still lives in Bloomington. Their four children are grown. He was photographer-author for *A Photographic Legacy: Arkansas Photographs from the FSA Collection; Monroe County in Focus; The Magnificent 92: Indiana Courthouses;* and *A Life Is More Than a Moment.*

**James H. Madison** is the Thomas and Kathryn Miller Professor of History and former chair of the Department of History at Indiana University. Among his books are *The Indiana Way: A State History* and *Eli Lilly: A Life.* His most recent book is *A Lynching in the Heartland: Race and Memory in America.*

**Scott Russell Sanders** was born in Tennessee and grew up in Ohio. He studied at Brown University before going on, as a Marshall Scholar, to complete a Ph.D. in English literature at Cambridge University. In 1971 he joined the faculty of Indiana University, where he is Distinguished Professor of English and director of the Wells Scholars Program. *Writing from the Center,* a personal account of the quest for a meaningful and moral life, won the 1996 Great Lakes Book Award. His most recent books are *Hunting for Hope, The Country of Language,* and *The Force of Spirit.*